FLIGHT
AND THE ARTISTIC
IMAGINATION

FLIGHT
AND THE ARTISTIC IMAGINATION

Sam Smiles

Compton Verney
in association with
Paul Holberton publishing

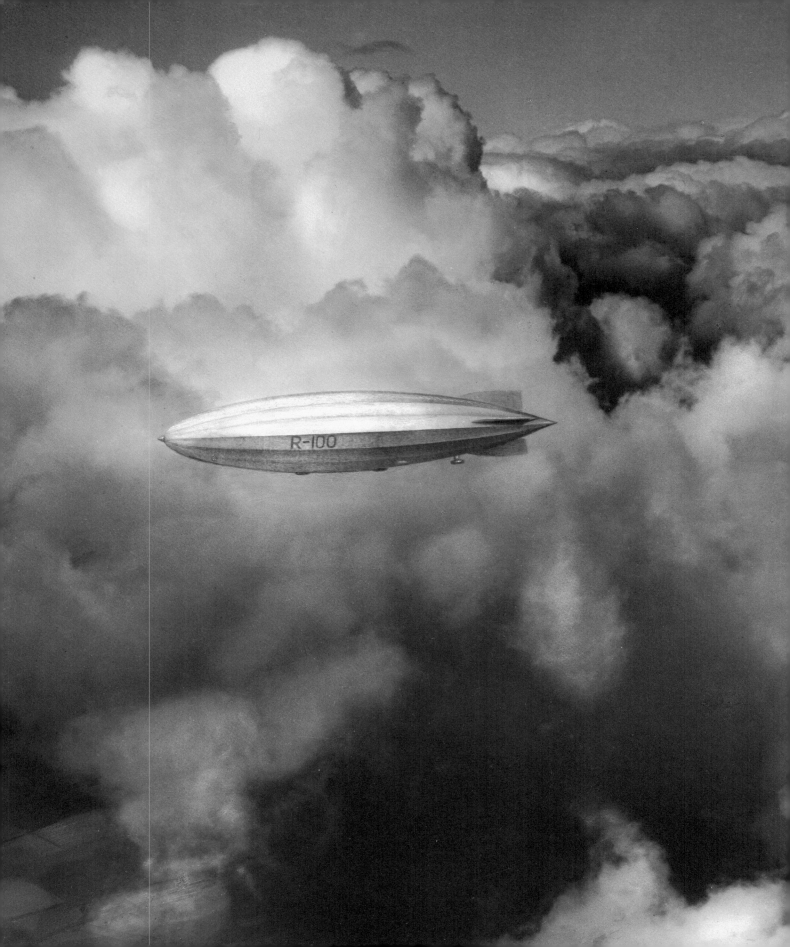

CONTENTS

The prospect that humankind might, one day, actually fly – a physiological feat which, as Professor Sam Smiles observes, humans simply cannot achieve unaided – has exercised, mesmerized and obsessed the world for centuries. It has also exerted a particular fascination for artists. Before human flight was actually achieved, artists sought to imagine the world from above, and to envision how they might conquer – with or without the help of wings, gods or heavenly vehicles – the empire of the sky. Following the first hot-air balloon ascent of 21 November 1783, artists were finally able to access this new world themselves, and to provide their earthbound audience with novel perspectives on the relationship of earth, sea and air. Art's horizons had been dramatically elevated; and with the coming of photography and, later, of film, the human race was never again to be so confident about its place in the universe.

This publication coincides with the major exhibition *Flight and the Artistic Imagination* (June – September 2012), the first-ever exploration of the pervasive influence that the command of the heavens had on artists both before and after 1783. It is the first to chart the growing preoccupation of painters, photographers and film-makers of the modern era with the possibilities and terrors of flight.

It has been, as always, a privilege to work with Professor Sam Smiles, and I would like to thank him publicly for his insight, and good humour. I must also thank Compton Verney's indefatigable art team, led by Alison Cox and Penelope Sexton, and indeed all of the gallery's staff, who have made this miraculous feat of flying possible.

Finally, I should like to extend my thanks to all those institutions and individuals who kindly lent their works to the exhibition which inspired this publication.

Dr Steven Parissien
Director, Compton Verney

FOREWORD

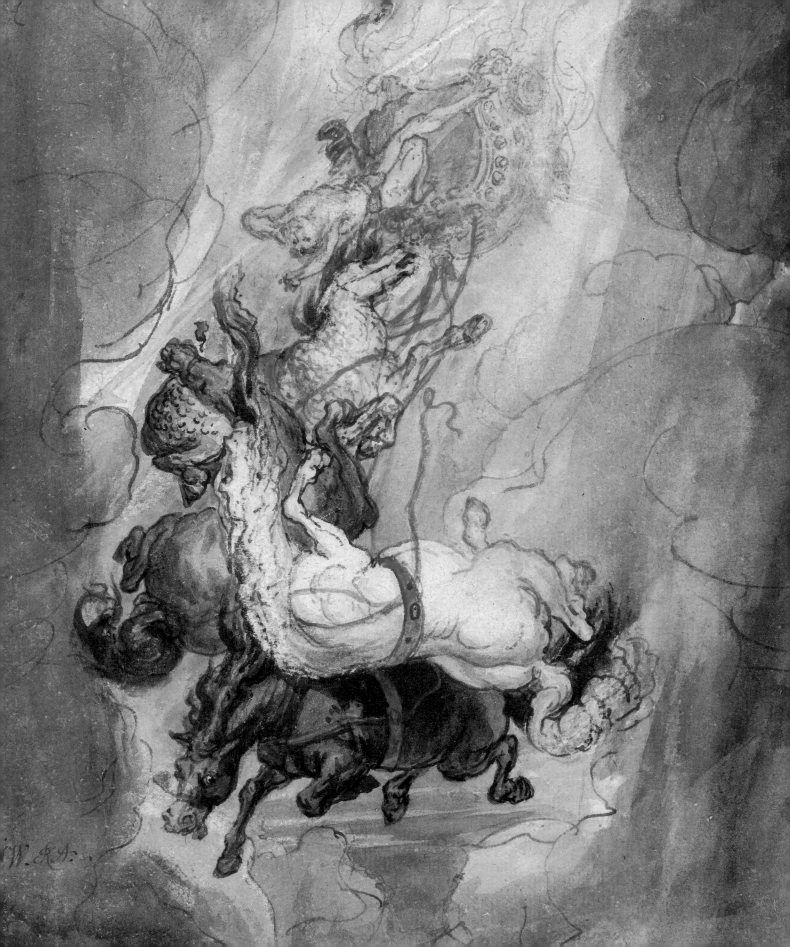

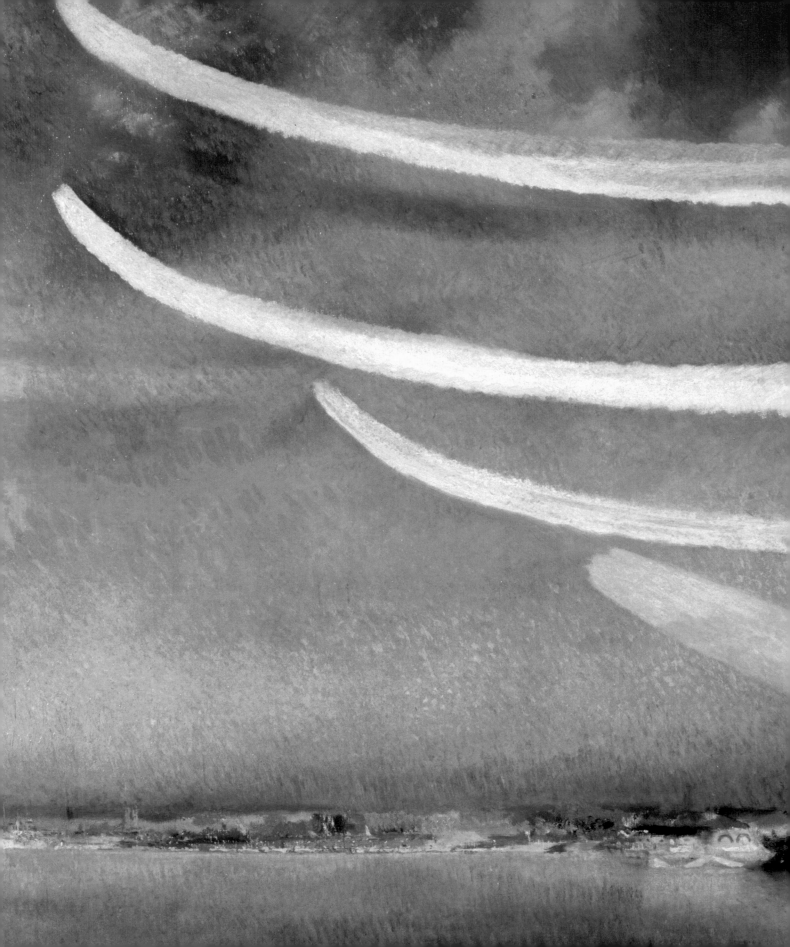

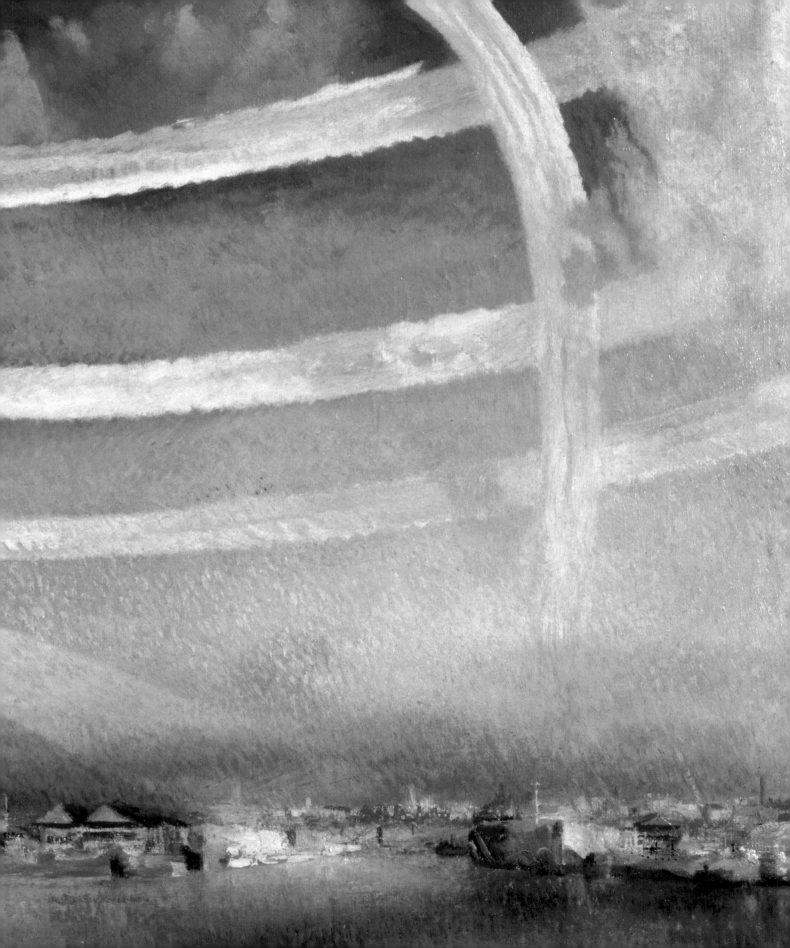

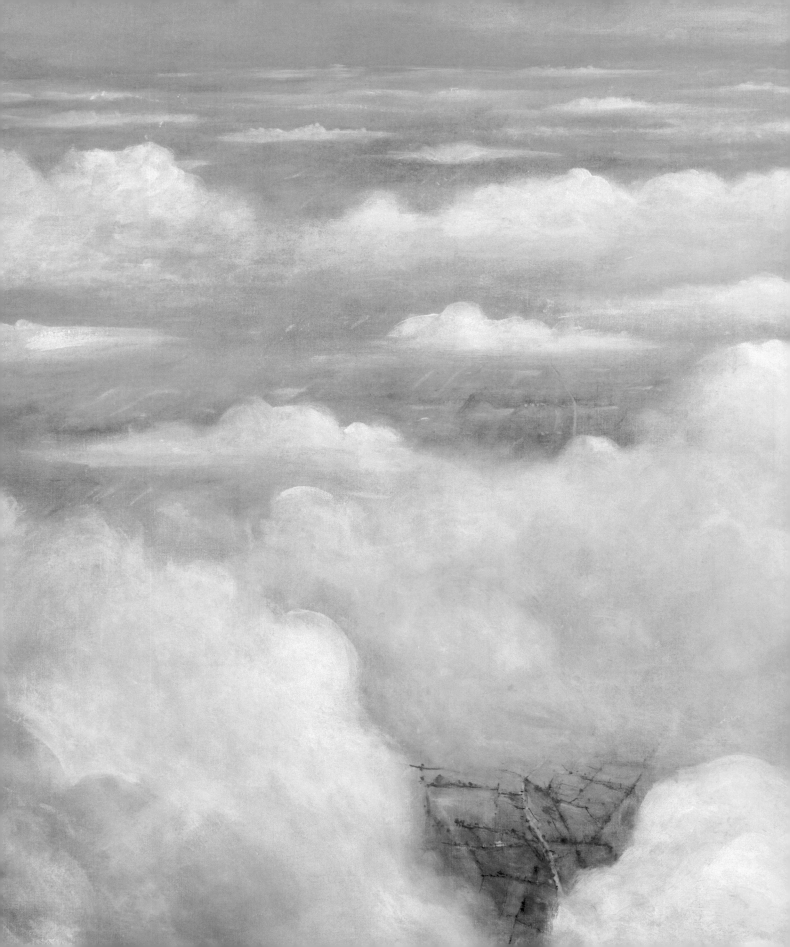

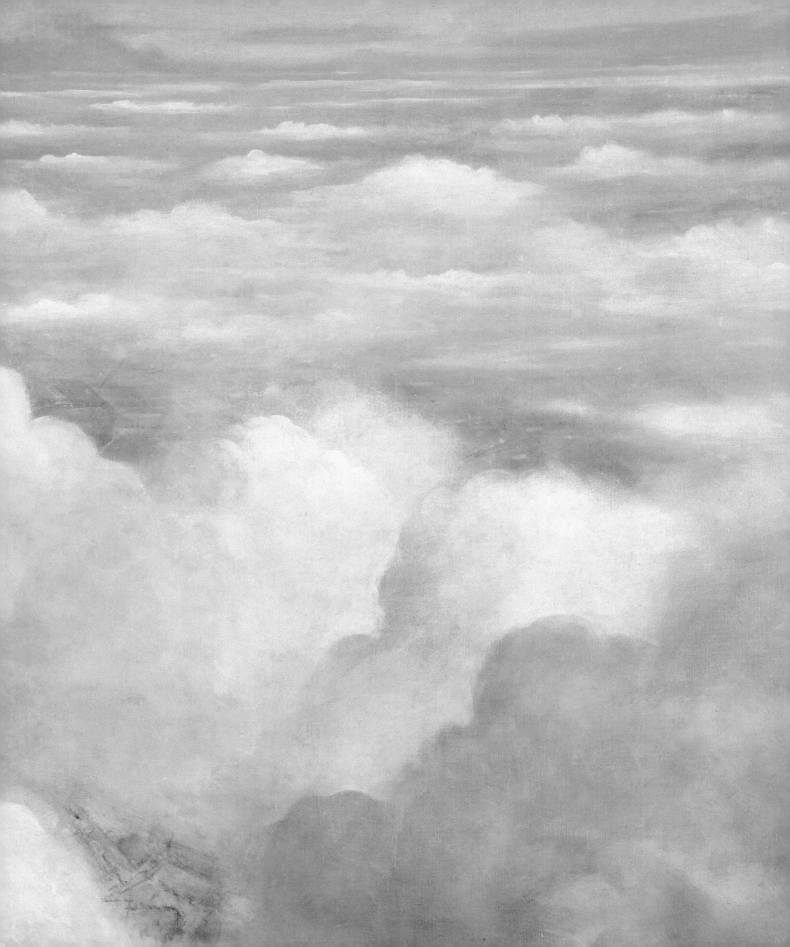

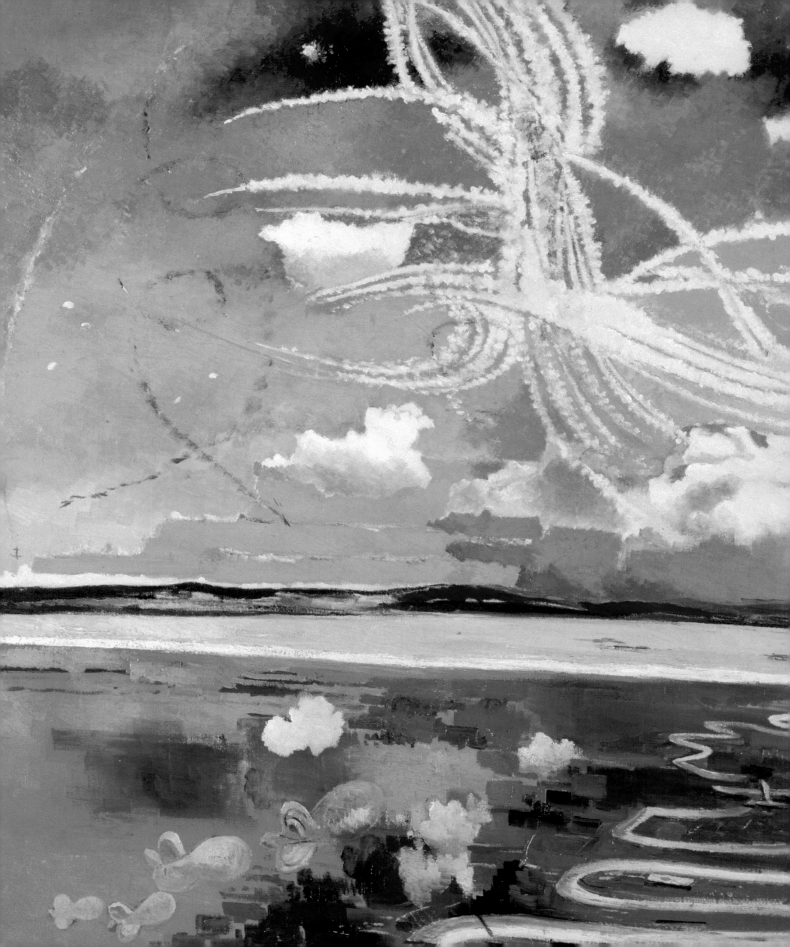

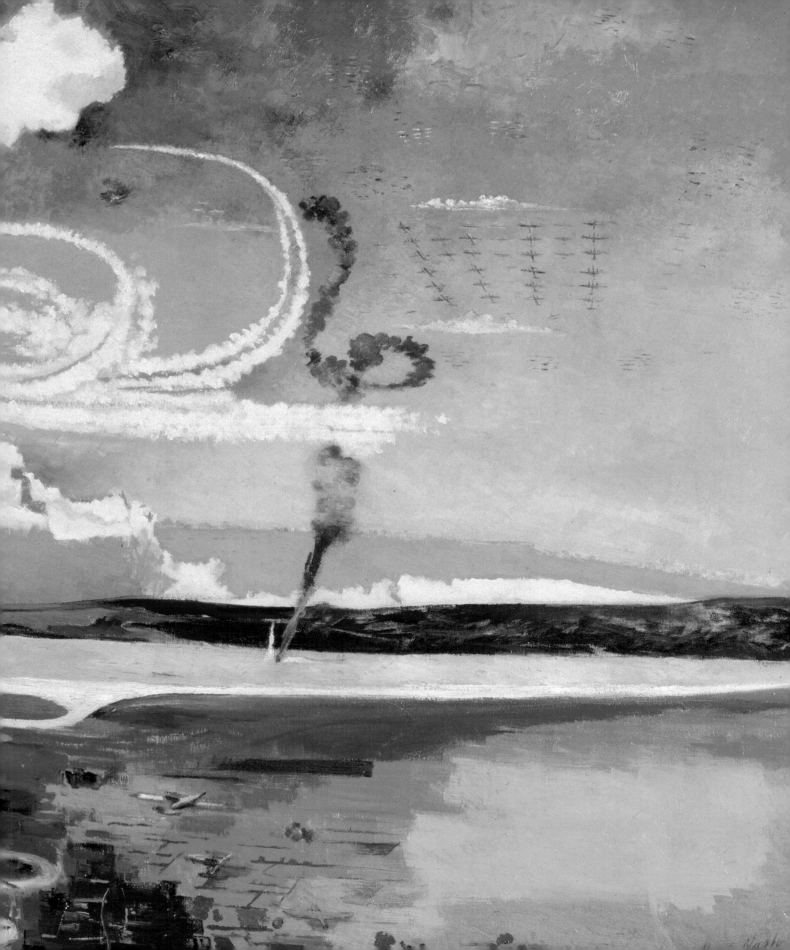

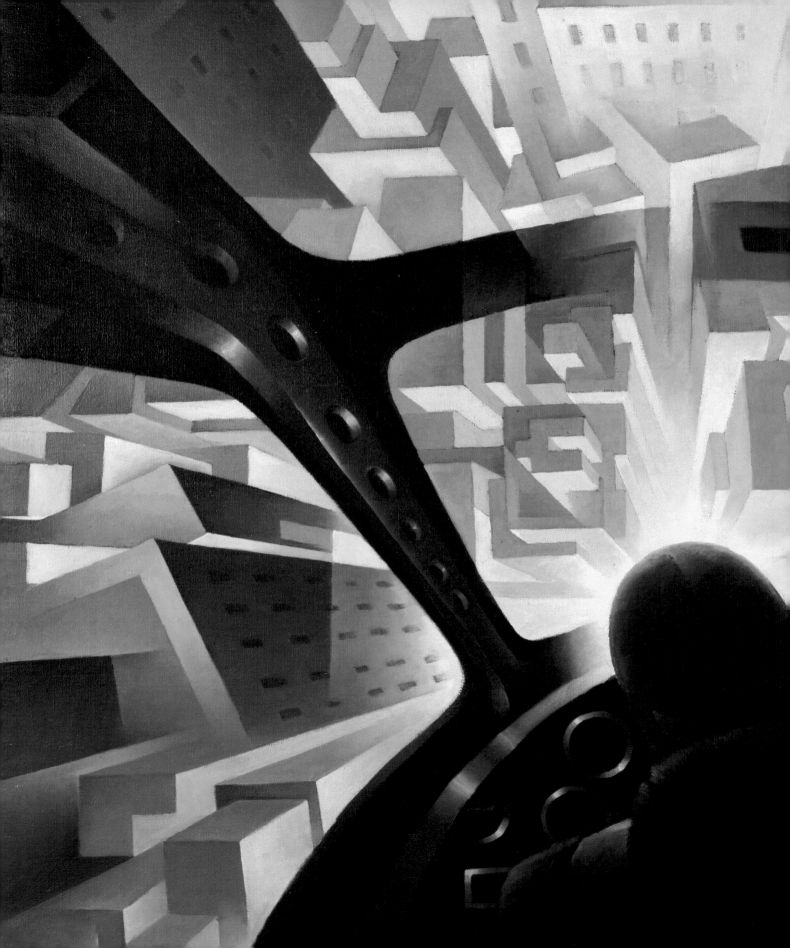

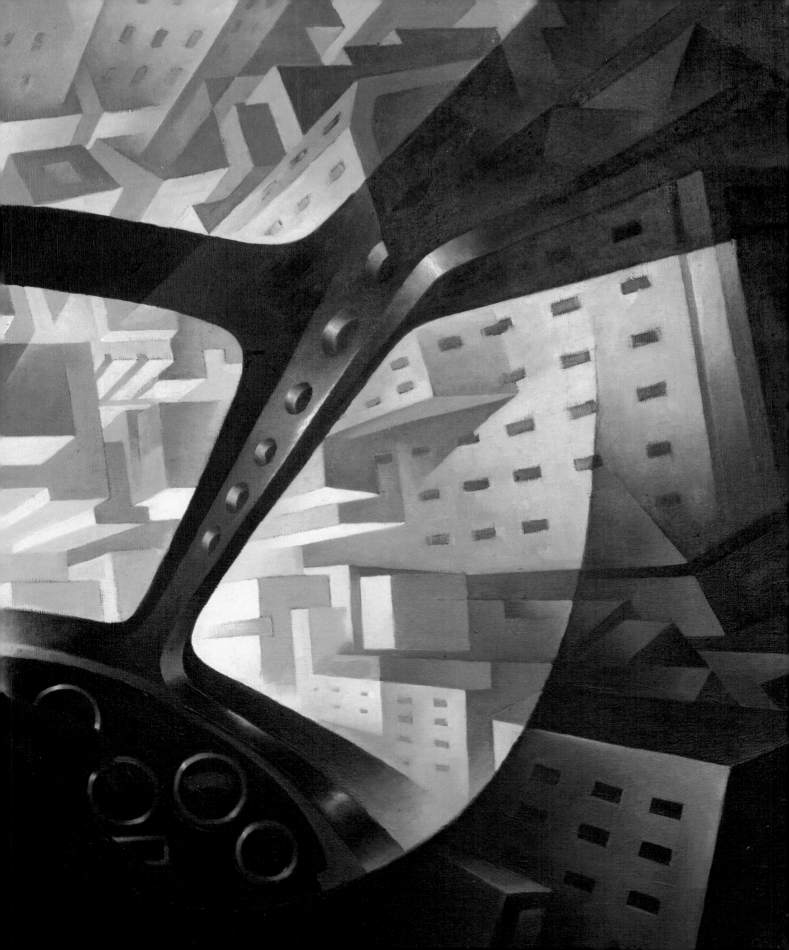

INTRODUCTION

Reminiscing about his early life, the American artist James Turrell has talked about how he learned to fly as a teenager, the inspiration he derived from the works of the French author and aviator Antoine de Saint-Exupéry, and his recurrent interest in what happens when "consciousness moves into and inhabits the sky".[1] Now that flying has become a routine and predictable occurrence for so many of us, such a remark seems at odds with what we experience as we shuffle through the check-in queue and then embark for our destination. Flying today is efficient, safe and sanitized. In-flight catering and entertainment focus our attention insistently on the familiar and the close at hand, distracting us from engaging with the thought that we are some six miles high and travelling at over 500 miles an hour. Secure in our pressurized cabin, our consciousness remains largely earthbound.

Our ancestors would find our blasé attitude to flying extraordinary, for the dream of escaping the tyranny of gravity has preoccupied mankind through the ages. The scientific and technical development of aeronautics saw humanity successfully voyage into the troposphere (from the 1780s onwards), the stratosphere (from the 1930s) and eventually, of course, into interplanetary space (from the 1960s). But, needless to say, the conquest of the air was not merely the preserve of those who were involved in devising new means of getting aloft. It also stimulated the creative imagination of many artists and writers, who recognized that the ability to fly would have a profound impact on our relationship to the earth and on our historical development.[2] The consciousness Turrell identifies can be detected in the creative responses to flying made by those who imagined flight before it was humanly possible, by those who witnessed the pioneers taking to the skies and by those who responded to the new discoveries of airborne vision.

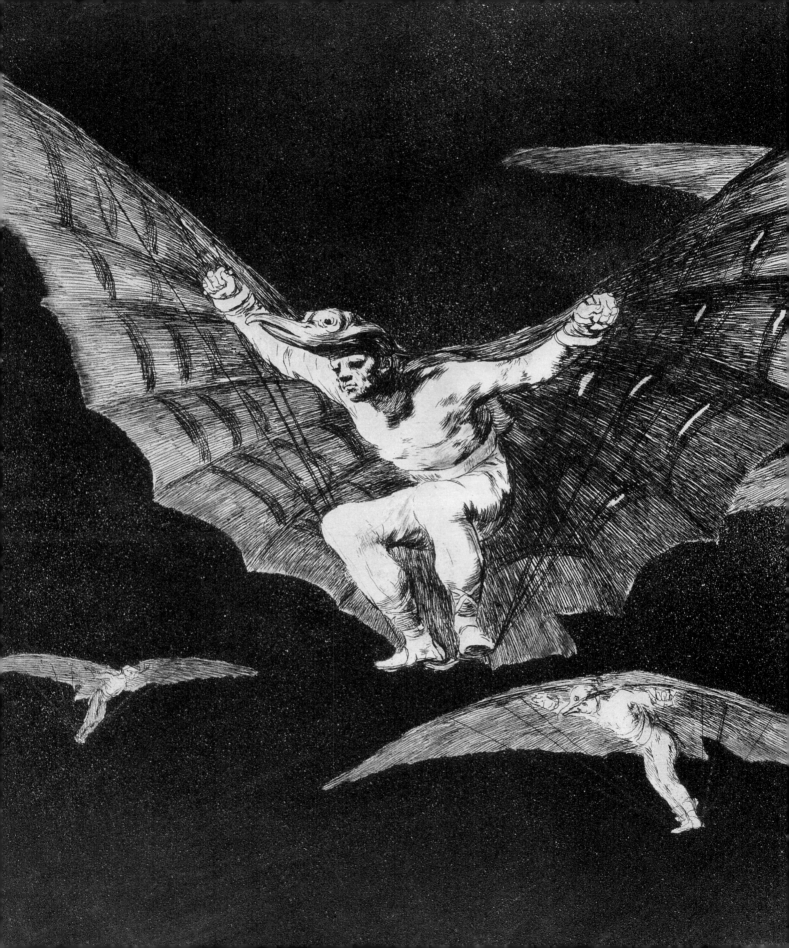

IMAGING FLIGHT

Flying is the only feat of movement we are physiologically incapable of achieving. It is no accident, therefore, that so many ancient religions placed their gods in the sky, a realm that no human could possibly inhabit. Many deities were winged, the ability to fly allowing them to move easily between the heavens and the earth. But wingless gods are also abundant in these traditions, and they, too, interact with human lives here below.

If the ability of the gods to move irrespective of gravity was the mark of their separation from human limitations, by the same token humans who ceased to be earthbound were trespassing on the gods' domain. Ancient Akkadian and Sumerian texts talk of mortals who attempted to ascend into heaven but were thrown back down.[3] Classical literature contains a number of similar stories, such as that of the demigod Phaeton, who attempted to drive the sun chariot but only fell back to earth (fig. 2). Artists were also inspired by tales of humans being carried aloft into the realm of the gods, stories such as Ganymede being abducted by Zeus in the form of an eagle (fig. 3), and the nymph Orythia being swept up by Boreas, the deity of the north wind (fig. 4). In addition to such unwilling victims, the worthy might also be taken into the heavens after their death, as seen in classical depictions of the apotheosis of heroes such as Herakles and mortals like the Roman general Germanicus, the emperor Antoninus Pius and his wife Faustina. In Christian art, Elijah (in his fiery chariot), Jesus, the Virgin Mary and various saints and martyrs are frequently shown ascending to heaven. The problem of how to represent the airborne body convincingly led to a multitude of solutions, with increasingly spectacular presentations of the blessed ascending into infinite space.

In Christian imagery winged angels are very familiar, an iconography that probably began in the fourth century AD and was derived from the winged figures found on classical sarcophagi. We see them in numerous contexts, sometimes earthbound, as in the Annunciation, but more often airborne or, in the case of Jacob's dream, ascending and descending a ladder between heaven and earth (fig. 6).[4] Mark Wallinger's video work *Angel* (1997) alludes to this tradition in its overall formal presentation, with passengers thronging the escalators in London's Angel underground station (fig. 7). In the foreground Wallinger, personifying Blind Faith, recites the opening lines of

1
GEORGE RICHMOND (1809–1896)
The Creation of Light, 1826
Tempera, gold and silver
on mahogany, 48 × 41.7 cm
Tate © Tate, London 2012

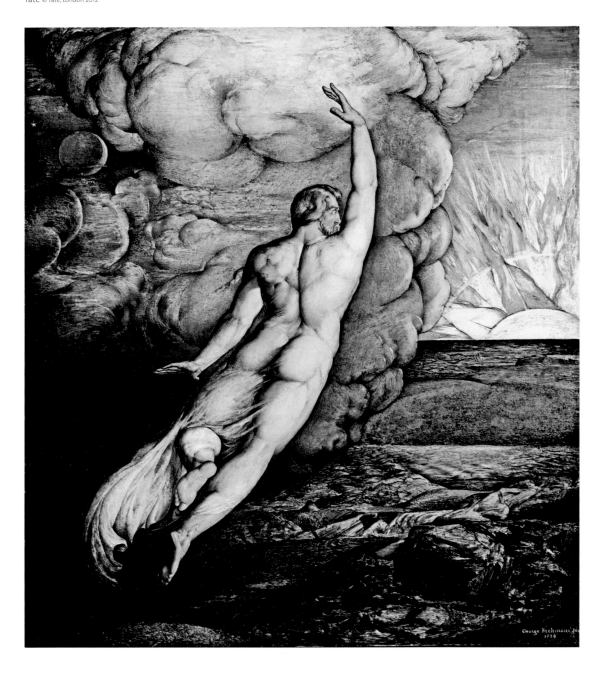

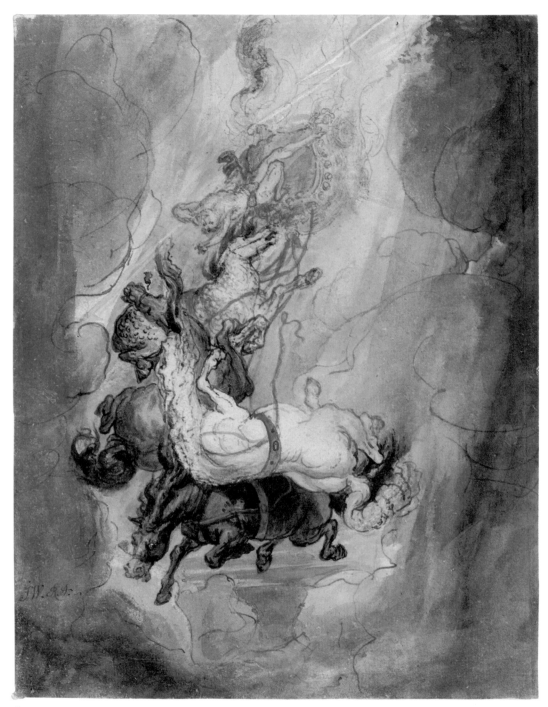

2
JAMES WARD (1769–1859)
*Study for 'The Fall of Phaeton', c.*1808
Graphite, pen and ink, and
watercolour on paper, 326 x 242 mm
Fitzwilliam Museum, Cambridge
© *Ibid.*

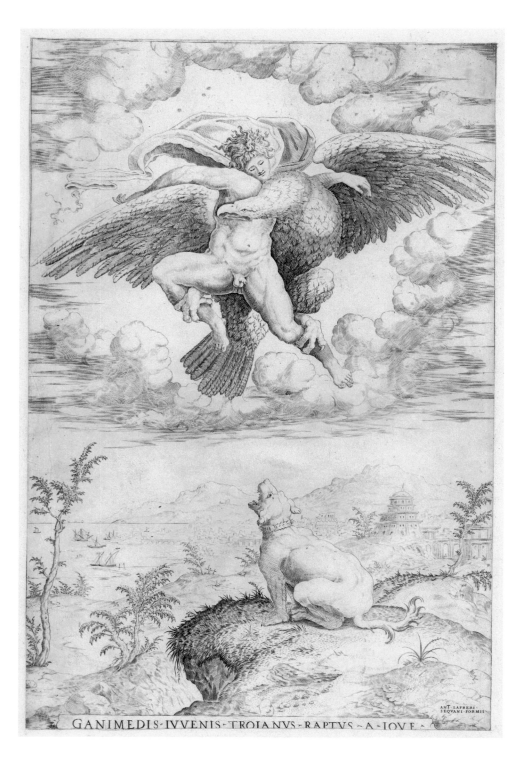

GANIMEDIS · IVVENIS · TROIANVS · RAPTVS · A · IOVE ·

3
NICOLAS BEATRIZET (ATTRIB.)
(c. 1507/15–1573 or after) AFTER
MICHELANGELO (1475–1564)
The Rape of Ganymede, 1542
Engraving, 384 x 275 mm
British Museum, London

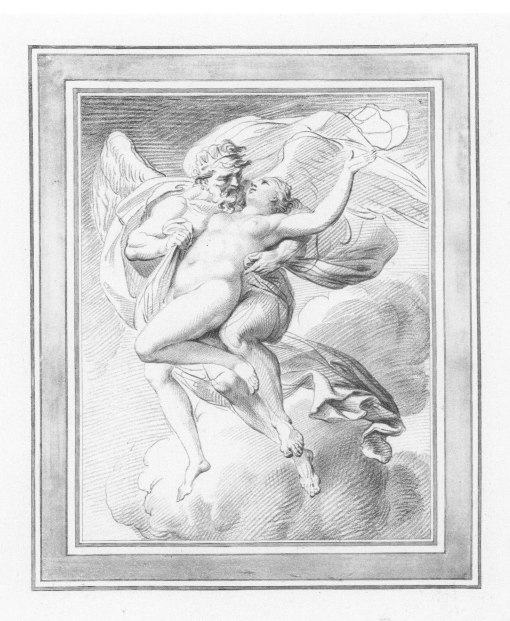

4
RICHARD EARLOM (1743–1822) AFTER
GIOVANNI BATTISTA CIPRIANI (1727–1785)
Boreas carrying away Orythia, 1787
Stipple with etching and aquatint,
printed in red ink, 305 x 251 mm
British Museum, London

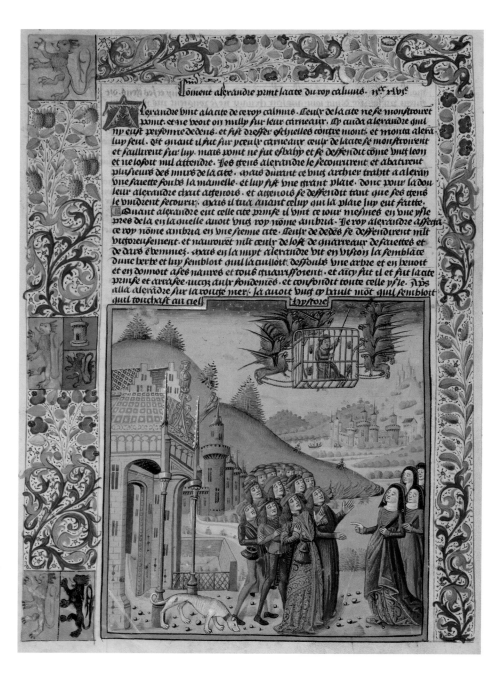

Coment alexandre print la cite du roy calinus. iiij.xxvj.

Alexandre vint a la cite de ce roy calinus. Ceulx de la cite ne se monstroient point. et ne veoit on nully sur leur carneaulx. Sy cuida alexandre quil ny eust personne dedens. et fist dresser eschielles contre mont. et monta alexandre luy seul. dit quant il fut sur yceulx carneaulx ceulx de la cite se monstroient et saillirent sur luy. mais point ne fut esbahy et se deffendit come vng leon et ne losoit nul attendre. ses gens alexandre le secourirent. et abatirent plusieurs des murs de la cite. mais durant ce vng archier traisit a alexan vne saiette soubz la mamelle. et luy fist vne grant plaie. donc pour la dou leur alexandre chaut atsenois. et atsenois se deffendit tant que ses gens le vindrent secourir. apres il tua auant celuy qui la plaie luy eut faitte.

Quant alexandre eut celle cite prinse il vint ce iour mesmes en vne ysle mes de la en laquelle auoit vng roy nōme ambira. Le roy alexandre assega ce roy nōme ambira en vne sienne cite. Ceulx de dedens se deffendirent mlt vigoreusement. et naurorent mlt ceulx de lost de quatreaulx desaiettes et de dars enuenimez. mais en la nuyt alexandre vit en vision la semblance dune herbe et luy sembloit quil la cuilloit dessoulz vne arbre et en beuoit et en donnoit ases naurez. et tous guarissoient. et aicy fut il et fut la cite prinse et arrasee iucqz aulx fondemens. et confondit toute celle ysle. apres alla alexandre sur la rouge mer. sa auoit vng sy hault mōt quil sembloit quil touchast au ciel.

Hystore

5
Miroir du Monde. Universal history from the Creation to the birth of Christ, vol. I
Normandy, before 1463
Bodleian Library, University of Oxford
MS. Douce 336, fol. 102v

Saint John's Gospel ("In the beginning was the Word …") before 'ascending' in the final moments of the piece.[5]

Many traditional accounts of human beings getting airborne were made more plausible by the aeronaut relying on the power of fabulous creatures that were able to fly in their own right. The winged horse Pegasus is the mount of Bellerophon, who eventually overreaches himself in a doomed attempt to fly to Mount Olympus. In another tradition Pegasus is ridden by Perseus to rescue Andromeda from the sea monster Cetus. In Islam, Hadith texts concerning the Isra' (night journey) and Mi'raj (heavenly ascension) tell how the winged steed Buraq carried Mohammed in one night from Mecca to "the farthest mosque" (Jerusalem) and then up to heaven to

6

UNKNOWN ARTIST (early 17th century)
Jacob's Ladder, from *Martin Luther (1483–1546)
Biblia : das ist, die gantze heylige Schrift Teutsch
Doct. Mart. Luth. : Jetzund von neuwen nach
der letzten Edition so D. Mart. Luth.,* 1606
Woodcut on paper
Cadbury Research Library: Special Collections,
University of Birmingham © *Ibid.*

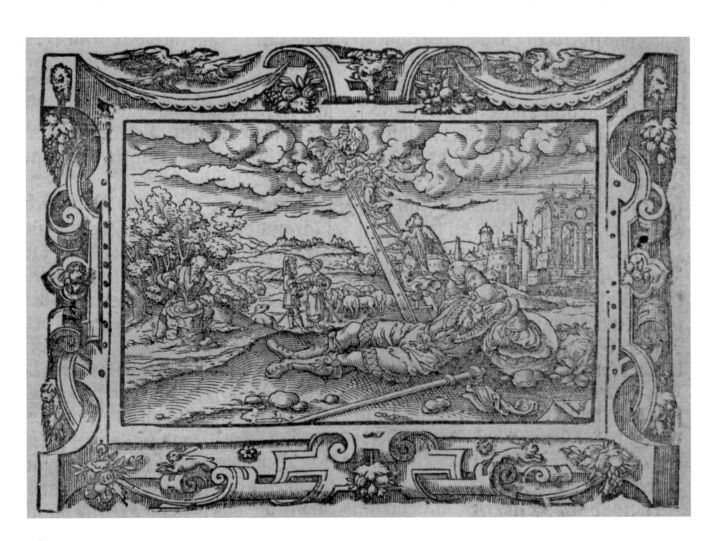

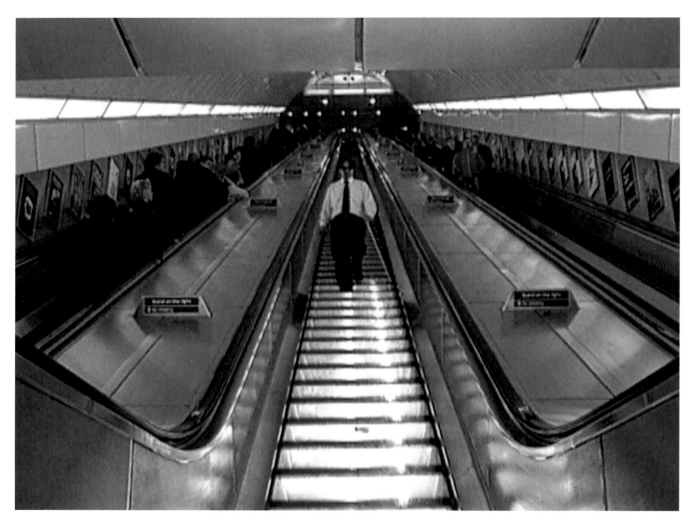

7

MARK WALLINGER (1959–)
Angel, 1997
Installation for video projection,
audio 7 minutes 30 seconds
© The artist, courtesy Anthony Reynolds Gallery, London

converse with the prophets, before returning to earth.[6] In *The Thousand and One Nights* Sinbad the Sailor ties himself to the legendary giant bird the roc and is carried so high that the earth below disappears from sight. A now rather forgotten story, originating in the third century AD, became popular in the Middle Ages and was frequently depicted. It tells of Alexander the Great's desire to expand his conquests by exploring the heavens. The vehicle he devised became airborne by harnessing griffins to it and enticing them to fly in pursuit of a piece of meat held in front of them (fig. 5). Although sent back to earth by divine power, in the time he was aloft Alexander saw the Earth below looking like a circular threshing floor, with the sea wound about it like a serpent.[7] Clearly, Alexander's supposed viewpoint is indebted to early world maps, but in imagining what the land seen vertically from above might look like, this story breaks new ground.

Audiences were also intrigued with tales of those exceptional individuals who managed to defy gravity in a more limited sense. The association of the body's ascension with extraordinary piety is captured in the depictions of devout priests who were able to levitate, among them Saint Francis of Assisi (fig. 8) and the seventeenth-century saint Joseph of Cupertino (the patron saint of aviators), both of whom were reported as being able to stay airborne while in ecstatic communion with God. However, the ability to move in the air has also been linked with the dark arts. In the apocryphal *Acts of Peter* is found the story of the magician and heretic Simon Magus, who hovered above the Forum in Rome until Saint Peter's prayers brought him crashing to earth. European folklore speaks of witches riding broomsticks often greased with a flying potion, a tradition that dates back to the Middle Ages, if not earlier.[8] Delacroix's famous lithograph *Mephistopheles in Flight*, made for a French edition of Goethe's *Faust*, brilliantly fuses the idea of the fallen angel with these old European superstitions (fig. 10).

Alongside these tales of supernatural ascents grew up another tradition of mortal flight. Of all the classical tales, the legend of Daedalus and Icarus has tended to dominate the Western imagination (figs. 11–15), not least because Icarus's recklessness in flying too close to the sun was a warning against youthful hubris. Concentration on Icarus's tragic death has, though, overshadowed the success of his father's invention, variations of

CIRCLE OF FRANCISCO DE
ZURBARÁN (1598–1664)
A Levitation of St Francis, undated
Oil on canvas, 100 x 81.6 cm
The Bowes Museum, Barnard
Castle, County Durham © *Ibid.*

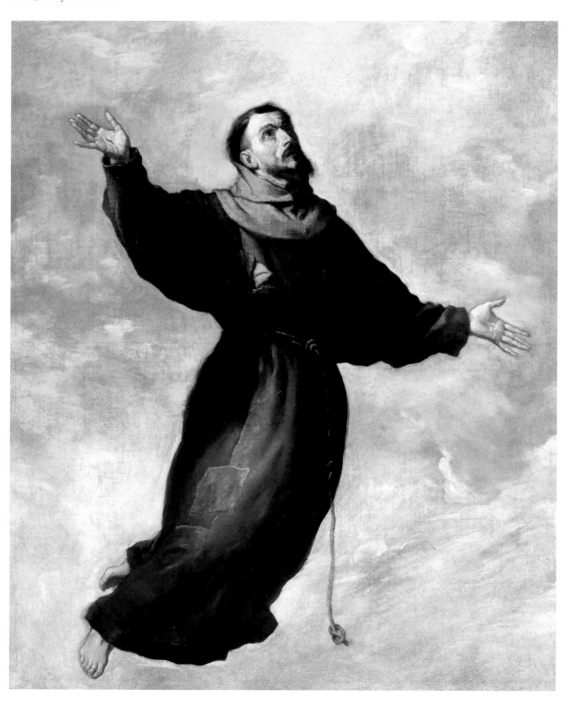

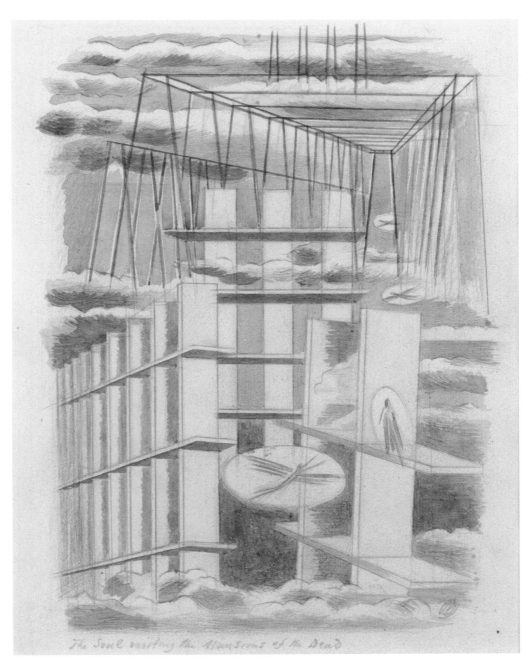

The Soul visiting the Mansions of the Dead

9

PAUL NASH (1889–1946)
*The Soul visiting the Mansions
of the Dead*, 1932
Watercolour, 46 x 39 cm
British Council Collection
© Tate, London 2012

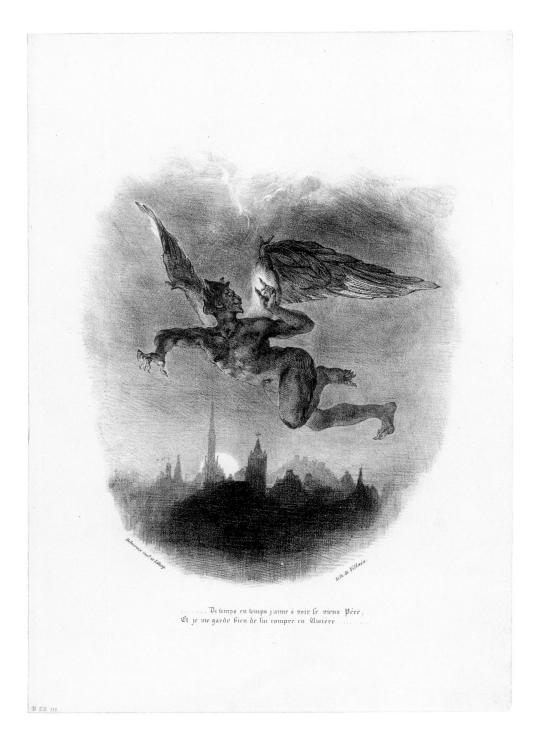

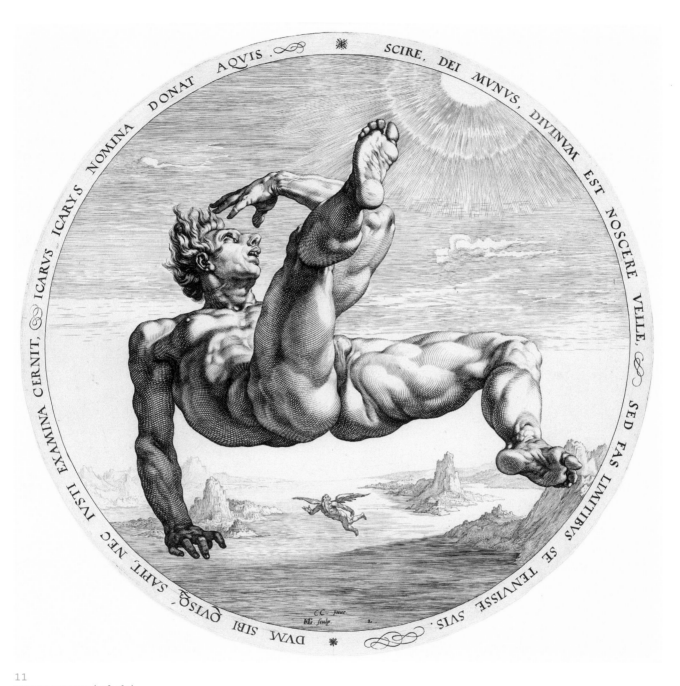

11
HENDRIK GOLTZIUS (1558–1617)
AFTER CORNELIS CORNELISZ. VAN
HAARLEM (1562–1638)
The four disgracers: Icarus, 1588
Engraving, 330 mm diameter
British Museum, London

12
FRANCESCO ALLEGRINI (1587–1663)
The Fall of Icarus, undated
Oil on canvas, laid down
on panel, 38.4 x 28.4 cm
Fitzwilliam Museum, Cambridge
© *Ibid.*

HERBERT DRAPER (1863–1920)
The Lament for Icarus, c. 1898
Oil on canvas, 182.9 x 155.6 cm
Tate © Tate, London 2012

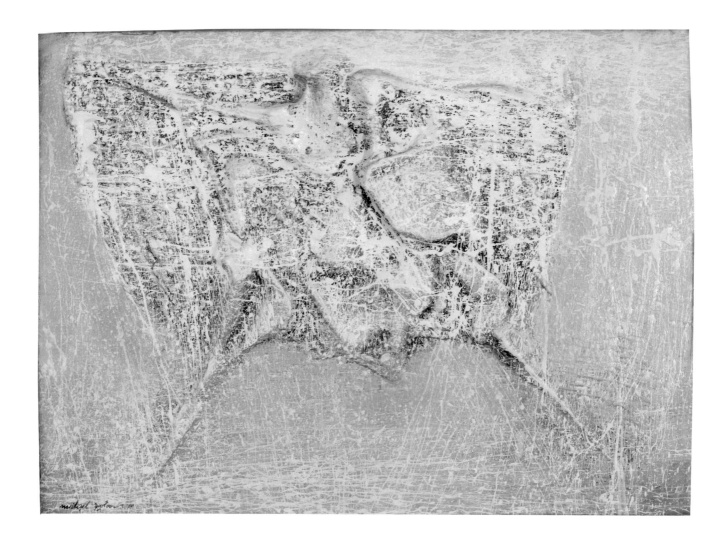

which can be found elsewhere in world mythology.[9] Practical experiments
in flight attempted to turn the legend into reality and are known from
the Middle Ages onwards.[10] Among them, Leonardo da Vinci's famous
investigations of bird flight and his proposals for various types of human-
powered flying machine are very well known (fig. 16). Using his observations
on the flow of water, he made the intellectual leap to investigate the flow of
air over a bird's wing and to develop theories of aerodynamics.[11] His example
was followed in the modern era by Vladimir Tatlin, who also studied bird
flight when devising his *Letatlin* of *c.* 1930–32 (the name melds the artist's

14
MICHAEL AYRTON (1921–1975)
Icarus in Flight, 1960
Oil on stucco relief, 40.6 x 50.8 cm
Arts Council Collection, Southbank
Centre, London
© Estate of the artist

15
HENRI MATISSE (1869–1954)
Published by Tériade (Paris)
Icarus – Plate VIII from illustrated
book *Jazz*, published 1947
Stencil print on paper, 41.9 x 26 cm
Victoria and Albert Museum, London
© Succession H. Matisse / DACS 2012

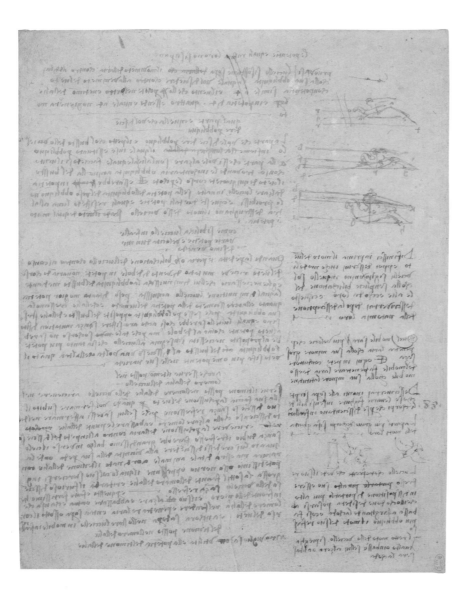

16

LEONARDO DA VINCI (1452–1519)
Notes on bird flight, c. 1511–13
Pen and ink, on coarse yellowish
paper, 272 x 208 mm
Royal Collection

Supplied by Royal Collection Trust /
© HM Queen Elizabeth II 2012

17
'Victorin prenant son vol',
engraving from Rétif de la
Bretonne, *La Découverte Australe
par un homme volant; ou le Dédale
français*, Paris, 1781

surname with the Russian verb to fly, *letat'*; fig. 18). Tatlin's interest in spatial dynamics as a sculptor found a logical extension in this project, which reintroduced the aspiration of individual ascension to a world dominated by powered flight.[12]

The fantasy of flight as a physical possibility for human beings is invoked in two idiosyncratic eigtheenth-century novels: Robert Paltock's *The Life and Adventures of Peter Wilkins* (1751), whose eponymous hero meets a winged race in Africa and lives among them, and Rétif de la Bretonne's *La Découverte Australe par un homme volant; ou le Dédale français* (1781), in which Victorin, the French Daedalus of the title, flies across the Pacific in a bodysuit that fans out like a corrugated kite (fig. 17). Both works went through a number of editions and were illustrated with engravings. Goya's

18

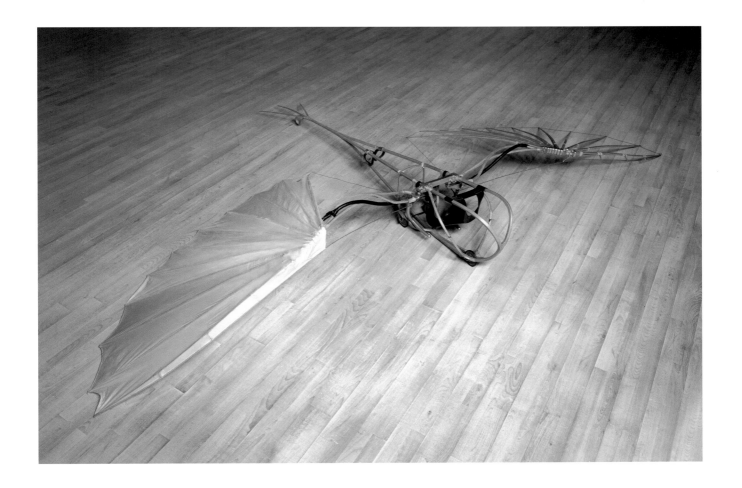

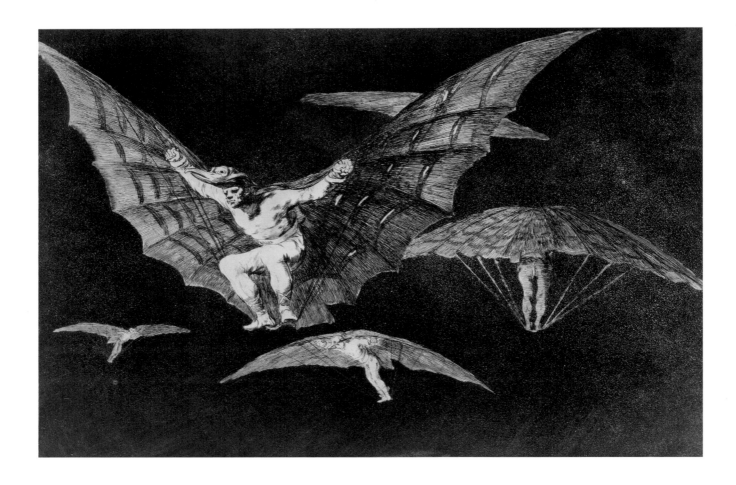

etching *Donde hay ganas hay maña* (Where there's a will there's a way),
made as part of the series *Los Disparates* (later known as *Los Proverbios*), picks
up the theme, but it is uncertain whether he is applauding the potential
of rational enquiry to overcome all the limitations on human freedom or
satirizing the credulous dreamers of fantastic schemes (fig. 19).

The popularity of unaided flying has never entirely gone away, even
after the advent of heavier-than-air powered machines. This is graphically
demonstrated in the proliferation of comics featuring flying superheroes
from the 1930s onwards – Superman, Wonderwoman, Hawkman, the Green
Lantern and many more (fig. 20). Perhaps its most curious manifestation
is found in the theories of Alfred Lawson, an important contributor to the
development of American aviation as well as a prophet of what the new

technology would produce. In 1916 he published an article anticipating the progress of flying over the next 8,000 years. By AD 3000, he believed, pilots would never land and would live solely in the upper air. As a result, by AD 10,000 physical evolution would see Homo sapiens become two biologically distinctive types, 'Alti-man' and 'Ground-man'. Alti-man would be an ethereal being, without substance and thus no longer needing a flying machine. Apprised of "great truths", able to grow food in the sky and control the weather, Alti-man would rule over Ground-man.[13] In Lawson's vision of the future Alti-man has effectively taken the place formerly inhabited by the sky gods of old.

20
PAUL M. SMITH (1969–)
From the series *Action* 2000
Digital photograph in a light box
© The artist

THE VIEW
FROM ABOVE

From the sixteenth century artists began producing bird's-eye views of towns and landscapes from an imaginary position in the sky. When based on actual places these images were essentially artistic hybrids, combining cartographic surveying with perspective and using an oblique view to bring the schematic form of the map into the world of 'ordinary' vision, as seen in Leonardo da Vinci's study *A bird's-eye view of the Val di Chiana* (fig. 21). The same methods could, of course, be used for the depiction of entirely imaginary scenes, such as the panoramic landscapes of his Flemish contemporary, Joachim Patinir. What is striking about the aerial view is the reorientation of the familiar that it displays: lifted above the world, we see the monuments of man as miniaturized, even insignificant. Moreover, the perspective cone centred on the viewing subject places the spectator at the point of maximum pictorial logic, with the world laid out for our inspection. Thus, by dint of its high prospect this is quite literally superior knowledge – the alternative designation for such prospects was the God's-eye view – and the observer in this elevated position is placed in a lofty position of power.[14]

With the coming of flight, what had been imaginary became real. In 1937, writing about the new use of photographic air survey for archaeology, John Piper celebrated how two modern technologies, flying and photography, had combined to produce a new arena for pictorial design. As he said:

> Flying (whether we do it ourselves or not) has changed our sense of spaces and forms and vistas enormously. From the air, hills flatten out and towns are seen at a glance ... the sea from the air has become something new to the senses: it is like nothing we have ever known The significant thing being that from the air *horizons vanish*.

Interestingly, Piper claims that flying itself had not actually created any new consciousness about spaces and vistas; it had simply served the new Modernist consciousness of the age. For Piper, it is no coincidence that air photography began at the same time that the horizon in Modernist landscape painting was thrown into doubt, along with all other representations of distance.[15]

21
PATRICIA MACDONALD (1945–)
Harrowed Fields/ Dragon Currents near Loch Ness, 1990
Cibachrome print, 39.9 x 26.8 cm
Scottish National Portrait Gallery, Edinburgh
Patricia Macdonald in collaboration with Angus Macdonald

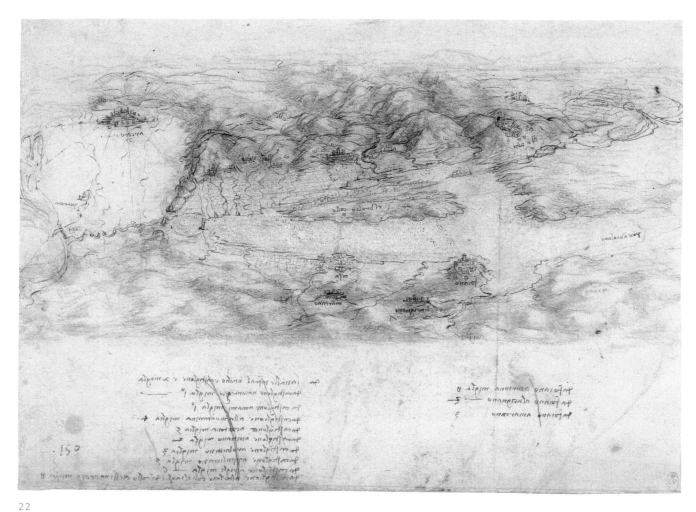

22
LEONARDO DA VINCI (1452–1519)
A bird's-eye view of the Val di Chiana,
c. 1503–04
Charcoal or soft black chalk, reworked
with pen and dark brown ink, brush and
brown wash, 209 x 281 mm
Royal Collection

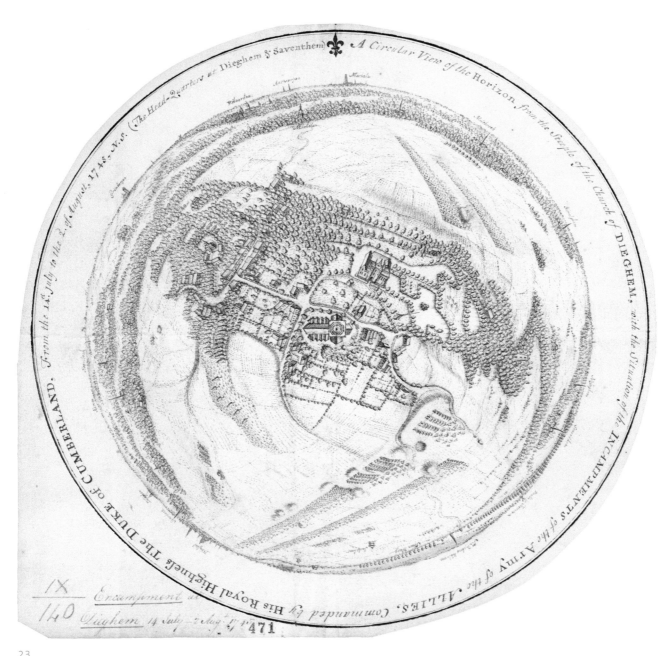

The text within the circular image reads:

A Circular View of the Horizon, from the Steeple of the Church of DIEGHEM, with the Situation of the INCAMPMENTS of the Army of the ALLIES, Commanded by His Royal Highness The DUKE of CUMBERLAND. From the 14th July to the 2d of August, 1745. N.S. (The Head-Quarters at Dieghem & Saventhem)

IX
140

Encampment at
Dieghem 14 July – 2 Aug 1745 **471**

23
GEORGE AUGUSTUS SCHULTZ (fl. 1740s)
A Circular View of the Horizon from the Steeple of
the Church of Dieghem, with the Situation of the
Incampments of the Army of the Allies Commanded
by His Royal Highness The Duke of Cumberland,
from the 14th July to the 2nd of August, 1745, N.S.
(The Head-Quarters in Dieghem & Saventhem)
Pen and Ink on paper, 265 mm diameter
Royal Collection

It is understandable that Piper, as an enthusiastic Modernist, identified these new perspectives with his immediate predecessors. In fact, the alteration of perception he talks about goes back much further, to the beginnings of flight. Manned ascent was finally achieved in the autumn of 1783, using the Montgolfier brothers' balloon in Paris.[16] From that moment the development of ballooning (or 'aerostation', as it was called initially) was rapid. The first flight in England was made by the Italian Vincent Lunardi at Moorfields in London on 15 September 1784, while Jean-Pierre Blanchard and the American Dr John Jeffries successfully flew from Dover to Calais the following January.[17] In the 1780s Lunardi, as the pioneer aeronaut in England, drew large crowds to witness his ascents. Something of their popularity as a public spectacle is seen in Julius Caesar Ibbetson's painting of his third flight, of 29 June 1785, from St George's Fields in London's Newington Butts (fig. 26).

Lunardi's balloon was involved in another pioneering venture on 8 September of that year. On this occasion he let an amateur, Thomas Baldwin, take a solo flight from Chester. Baldwin made drawings when airborne and these were reproduced as coloured engravings in *Airopaidia*, an account of his flight he published in 1786.[18] Baldwin's illustrations are the first ever made of the earth from mid-air. One of them combines vertical and horizontal views, with the outline of Chester at the centre of a circular panorama of the clouds seen from the balloon at its greatest elevation; the other depicts 'A Balloon prospect from above the Clouds', showing the landscape over which the balloon travelled, partially obscured by intervening clouds, with its flight line marked across it.

The new experiences of moving in the upper air are caught in many of the early accounts of aerostation: the unfamiliar appearance of the landscape below, the variety of the cloud formations, and the clarity of the atmosphere all called for new responses. Lunardi's immediate reactions to what he had observed in his first flight demonstrate at once that the familiar ground-based understanding of the world had been radically altered by balloon perspective:

... how shall I describe to you a view, such as the antients (*sic*) supposed Jupiter to have of the earth, and to copy which there are no terms in any language. The gradual diminution of objects, and the masses of

24

LOUIS BONVALET (c. 1748–1818) AFTER
CLAUDE LOUIS DESRAIS (1746–1816)
*Apparition du Globe Aerostatique de Mr
Blanchard, entre Calais et Boulogne, parti
de Douvres le 7 de Janvier 1785 a 1 heure 1/2*
Engraving on paper, 380 x 302 mm
Royal Aeronautical Society (National
Aerospace Library)
© *Ibid.*

light and shade are intelligible in oblique and common prospects.
But here everything wore a new appearance, and had a new effect.[19]

What Lunardi and Baldwin experienced for the first time was not
simply the new aspect of clouds in the upper air, but something of startling
novelty for the business of representation. When Lunardi refers to "oblique
and common prospects", he means the perspectival devices utilized in
traditional bird's-eye views, in which the landscape unrolls gradually from

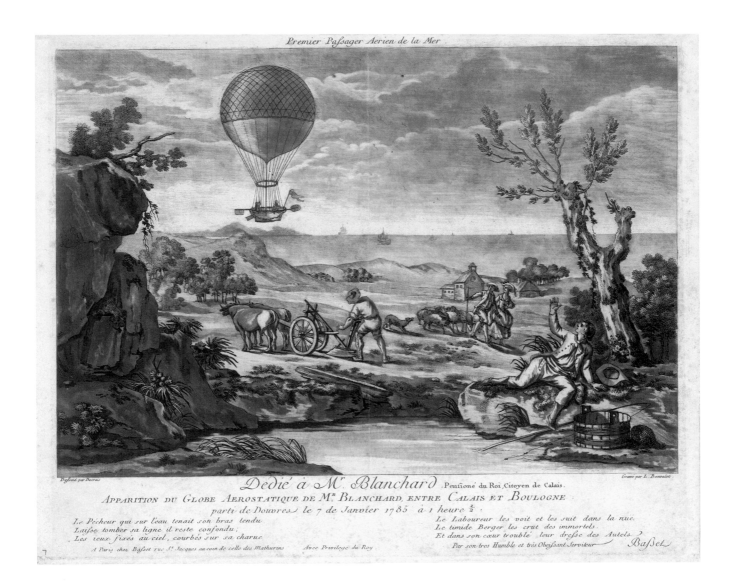

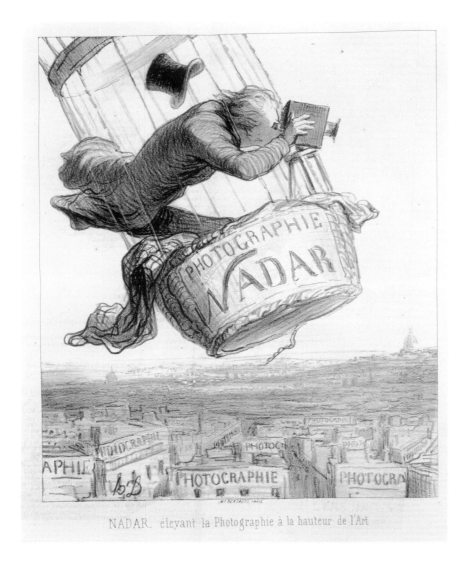

27

HONORE DAUMIER (1808–1879)
*Nadar (1820–1910) elevating Photography
to the height of Art*, published 1862
Lithograph, 45.5 x 32 cm
The Stapleton Collection
© The Stapleton Collection / Bridgeman Art Library

NADAR élevant la Photographie à la hauteur de l'Art

Relatively few balloonists made sketches when aloft, but Gaspard-Félix Tournachon, better known by his *nom de plume* of 'Nadar', pioneered aerial photography when he took a collodion photograph at a height of 262 feet from a tethered balloon on the outskirts of Paris in December 1858 (see fig. 27). A year later an American, James Wallace Black, photographed Boston from 1,200 feet.[20] In these early experiments the short interval between exposing the plate and developing it required a darkroom to be included in the basket, but after the invention of dry plates in 1871 and roll film in 1875 the possibilities for aerial photography developed apace. Cameras could be attached to unmanned balloons, to kites, to rockets and even to pigeons.[21] The photographs taken by the balloonist Eduard Spelterini

are perhaps the apogee of these developments from an aesthetic point of view. From about 1893 Spelterini began taking beautifully composed airborne photographs, which he showed as coloured slides in lectures given across Europe (fig. 28).[22] Alfred G. Buckham joined the Royal Navy Air Service as a reconnaissance photographer in 1917, and after the war specialized in aerial photography, using a heavy plate camera. The work he produced in the 1920s and 1930s is marked by his brilliant exploitation of the potential of the airborne view, its extraordinary perspectives and dramatic contrasts in light and shade, to stage a modern sublime (figs. 29–31).[23]

28
EDUARD SPELTERINI (1852–1931)
Mer de Glace glacier with Aiguilles de Chamonix – the peaks of the Mont Blanc chain – in the background, 8 August 1909
Lithograph
Swiss Museum of Transport, Lucerne
Lithograph courtesy of Verlag Schneidegger & Spiess, Zurich, Switzerland

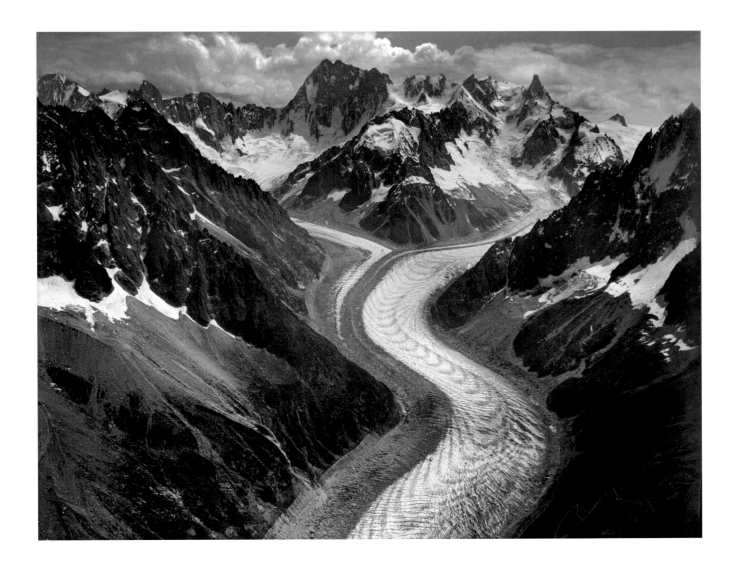

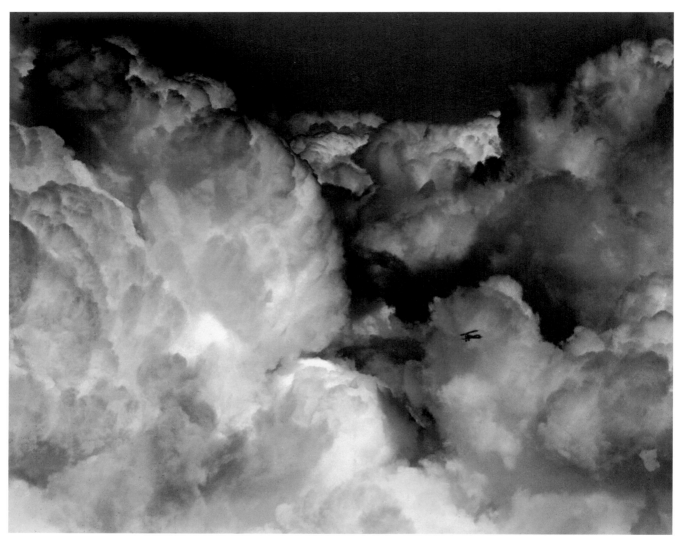

29

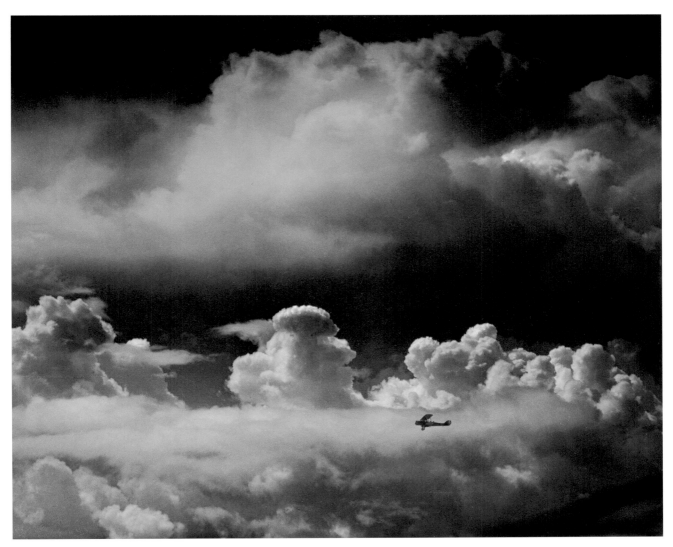

30
ALFRED G. BUCKHAM (1879–1956)
Cloud Turrets, c. 1920
Silver gelatine print, 38 x 45.7 cm
Scottish National Portrait Gallery,
Edinburgh, purchased with assistance
of the Art Fund, 2008
© Richard and John Buckham

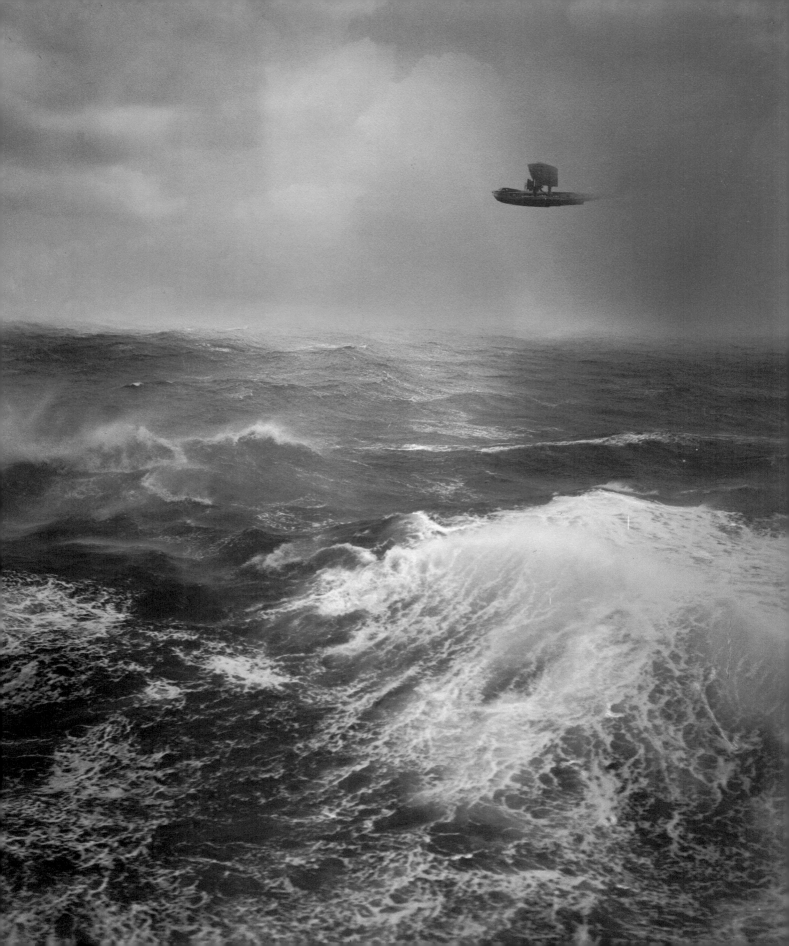

Although ballooning became familiar during the nineteenth century as a public spectacle and as an entertainment, allowing more people to experience what Lunardi and Baldwin had so vividly described, the creative potential of the airborne view for fine artists went largely unexamined. A rare exception to this was J.M.W. Turner's letter of March 1837 to the lawyer Robert Hollond, who had undertaken a balloon flight the previous November from London to Weilburg in Germany: "Your Excursion so occupied my mind that I dreamt of it, and I do hope you will hold to your intention of making the drawing, with all the lines and colours of your recollection."[24] What Hollond had discussed with Turner was not, in fact, turned into any sort of visual representation, as far as we know; and the scenes included in J.H. Grieve's 1836 diorama of the trip, the *Aeronautikon*, which were also issued as lithographs, were of the land below as opposed to the sky above.[25] Likewise, the illustrations in the published account of the flight only include one aerial view – of the balloon flying above Liège at night, with the numerous furnaces of the region clearly visible below. But the text indicates why Turner wanted to see drawings of what Hollond had observed:

> Behind us the whole line of the English coast, its white cliffs melting into obscurity, appeared sparkling with the scattered lights, which every moment augmented ... on either side below us the interminable ocean spread its complicated tissue of waves ... on the opposite side a dense barrier of clouds rising from the ocean like a solid wall fantastically surmounted, throughout its whole length, with a gigantic representation of parapets and turrets, batteries and bastions ... appeared as if designed to bar our further progress.[26]

Had Turner taken to the skies himself he would, no doubt, have been struck not only by the new visual sensations altitude afforded but also by the dynamism of flight. Certainly, there were aspects of his own practice that already presented an embodied relationship to nature, even with static observation; but as a moving subject that embodiment would have been heightened. Peter Lanyon, writing in the 1950s and reflecting on his experiences as a glider pilot, was clear that the sensibility born of flying had

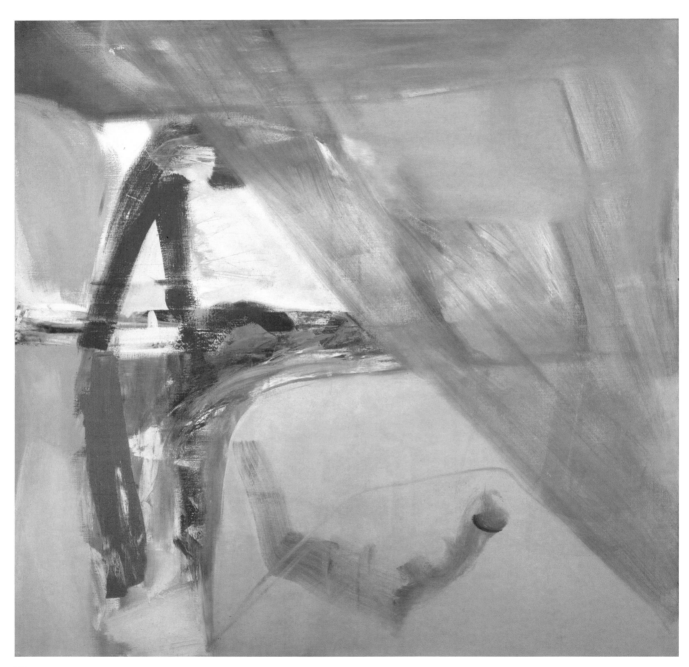

32
PETER LANYON (1918–1964)
Soaring Flight, 1960
Oil on canvas, 152.4 x 152.4 cm
Arts Council Collection,
Southbank Centre, London
© Sheila Lanyon. All Rights Reserved, DACS 2012

a direct link with Romantic landscape (fig. 32). For Lanyon, John Constable's sky studies showed "man taking part in the play himself and not as spectator ... anticipating twentieth-century journeys into space".[27] Turner, likewise, was considered a precursor:

> Turner certainly ... used quite extensively a spiral where you felt you were being drawn into a spiral and it got smaller and smaller away into the distance. Today it's possible I think, and this is why I do gliding myself, to get actually into the air and get a further sense of depth and space into yourself, as it were, into your own body, and then carry it through into a painting. I think this is a further extension of what Turner was doing.[28]

As these remarks demonstrate, the paintings Lanyon produced after he took up gliding are not mere reportage of the new vistas visible from altitude. Instead, his understanding of the new vision that flying provokes, at one with the elements, floating in light and air, highlights the immediacy of experience and its existential implications.

Artists responded to the advent of powered flight more quickly than they had to balloons. In 1909, Marinetti's *Manifesto of Futurism* included the declaration: "We will sing ... of the sleek flight of aeroplanes whose propellers chatter in the wind like banners and seem to cheer like an enthusiastic crowd."[29] Although a few of the original Futurist painters made allusions to flight in the works they produced in the 1910s, the centrality of flight for artistic innovation in Italy was promoted in the so-called 'Second Futurism', which developed in the 1920s. A major expression of this movement was Aeropittura (aero painting), the manifesto for which, published in 1929, stated that: "The changing perspectives of flight constitute an absolutely new reality that has nothing in common with the reality traditionally constituted by a terrestrial perspective."[30] At its height almost 100 artists (including sculptors) aligned themselves with the Aeropittura tendency. Tullio Crali was one of the painters who contributed significantly to Aeropittura, and his *Incuneandosi nell'abitato* (Nose dive on the city) has become one of its best-known images (fig. 55).

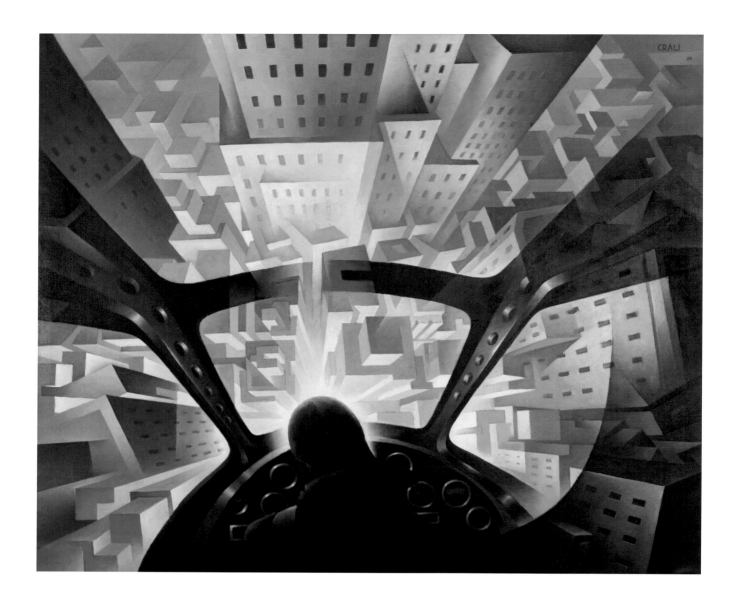

33
TULLIO CRALI (1910–2000)
Incuneandosi nell'abitato
(Nose dive on the city), 1939
Oil on canvas, 130 x 155 cm
Museo di Arte Moderna e
Contemporanea di Trento e Rovereto
© *Ibid.*

In Russia the widespread enthusiasm for aviation also had an important impact on the arts.[31] The poet Ivan Aksenov noted in 1914 that aerial photographs "introduce the most unexpected combinations of surface with axes and ... create unexpected visual sensations".[32] From 1913 Kasimir Malevich made paintings alluding to aviation, some of which seem to have made use of the reduction of details in aerial photography from above (fig. 34). The simplification of the visual field exhibited in photographs of aeroplanes flying against blank skies may also have helped him to develop his characteristic style, which positioned abstract elements against the

34

KASIMIR MALEVICH (1878–1935)
Suprematist Composition:
Airplane Flying, 1914–15
Oil on canvas, 58.1 x 48.3 cm
Museum of Modern Art, New York
(MoMA)

Purchase. Acquisition confirmed in 1999 by
agreement with the Estate of Kazimir Malevich
and made possible with funds from the Mrs
John Hay Whitney Bequest (by exchange)

© 2012. Digital image, The Museum of
Modern Art, New York / Scala, Florence

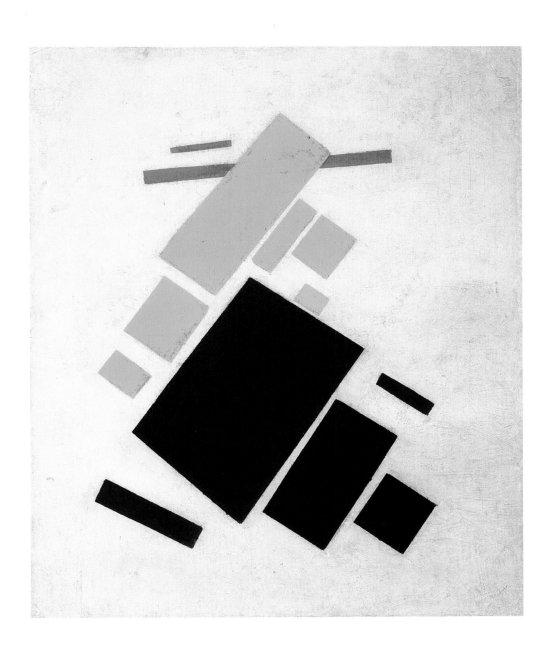

suggestion of infinite spatial recession. For Malevich, the aeroplane was far more than a technological development; it was something that could be better understood as a manifestation of human will, "nothing other than a yearning for speed ... for flight ... which seeking an outward shape, brought about the birth of the airplane".[33]

In France Louis Blériot made the first successful flight across the Channel in July 1909 and ignited public enthusiasm for aviation. The critic Arsène Alexandre was one of the earliest to recognize what opportunities the new technology presented for artists, and published the article 'L'art et l'air' shortly afterwards.[34] A number of French painters were motivated by the new technology, not least because France now led the development of the aeroplane, with the rapid proliferation of competitions, air shows, exhibitions, advanced manufacturing techniques and pilot training.[35] The phrase 'notre avenir est dans l'air' (our future is in the air) was incorporated by Picasso in three paintings of 1912, while the minor Cubist Roger de la Fresnaye painted La conquête de l'air in 1913. Fernand Léger recalled his visit to the Paris Air Show with Marcel Duchamp and Constantin Brancusi: Duchamp, impressed by the technical refinement of propellers, apparently remarked to Brancusi that "Painting is finished! Who can do better than this propeller? Tell me, can you do that?"[36] Léger made the propeller the subject of two paintings in 1918, both called Les Hélices, and the motif appears in other works made shortly afterwards, notably L'Aviateur of 1920. It is also possible that Brancusi's Bird in Space series, albeit concerned with an organic creature, in its morphology makes reference to the way a propeller transforms matter into energy (fig. 35).[37]

Robert Delaunay also took inspiration from the new technology. In L'équipe de Cardiff (The Cardiff team) of 1912–13, he depicts a rugby match with the players leaping for the ball,

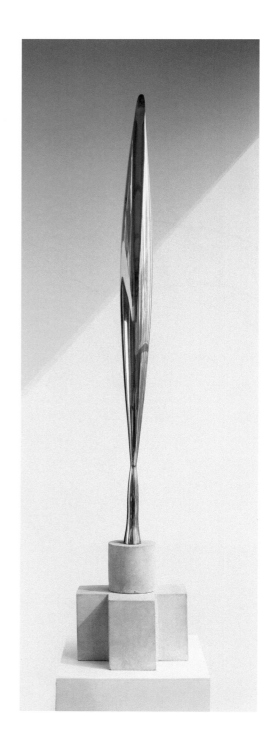

while in the sky far above flies a biplane (fig. 36). Behind the players an 'Astra' billboard refers to the French company that produced Wright Flyers under license. Delaunay returned to the subject in another painting of 1913, *Soleil, tour, aéroplane* (Sun, tower, aeroplane), and in 1914 painted his *L'hommage à Blériot*. The American artist Marsden Hartley, working in Germany at the time, was influenced by Delaunay's tribute to Blériot when he produced *The Aero* in 1914 (fig. 37). The red spot in the upper half of this highly abstracted painting refers to his experience of the flames emitted from the engines of airships as they passed overhead.[38]

Another early American creative response to powered flight was by Stanton Macdonald-Wright, who wrote an article in 1919 entitled 'Influence of Aviation on Art: The Accentuation of Individuality'.[39] He painted *Aeroplane Synchromy in Yellow-Orange* in 1920, which shows in prismatic colour the propeller, wings and undercarriage of an aeroplane climbing above roofs and hills, to convey the experience of looking down at the landscape from the air (fig. 39). When the painting was exhibited in Los Angeles that year, Macdonald-Wright discussed in the catalogue how aviation had changed human perception and now "symbolized an expanded consciousness".[40]

In the 1930s Arshile Gorky joined the mural division of the Works Progress Administration's federally organized Art Project, an initiative for artists that was devised as part of Roosevelt's 'New Deal' to stimulate economic recovery, and was given a commission to produce a mural for Newark Airport, which he worked on from 1935 to 1937 (fig. 38).[41] He chose to concentrate on the unique and distinctive attributes of the new technology:

> An airplane is composed of a variety of shapes and forms and I have used such elemental forms as a rudder, a wing, a wheel and a searchlight to create not only numerical interest but also to invent within a given wall-space plastic symbols of aviation. These symbols are the permanent elements of airplanes that will not change with the change of design. These symbols, these forms, I have used in paralyzing disproportions in order to impress upon the spectator the miraculous new vision of our time.[42]

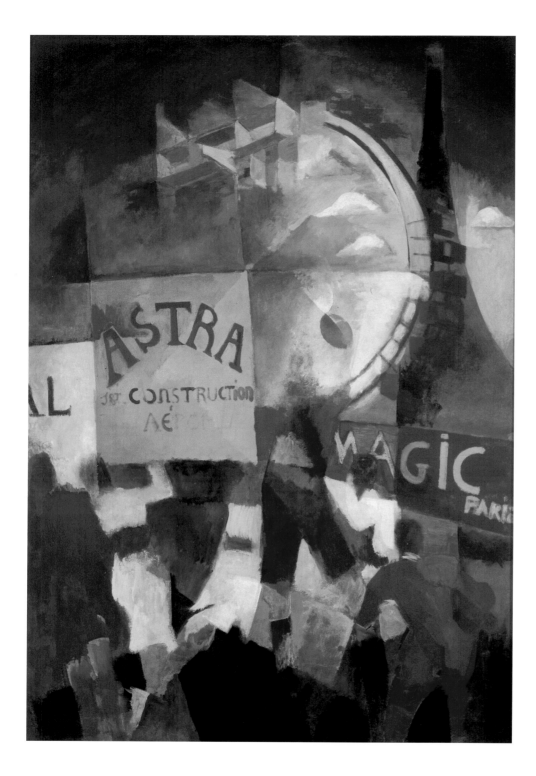

36
ROBERT DELAUNAY (1885–1941)
L'équipe de Cardiff, 1913
Oil on canvas, 146.8 x 114.2 cm
Collection Van Abbemuseum,
Eindhoven, The Netherlands
Photograph by Peter Cox, Eindhoven

37

MARSDEN HARTLEY (1877–1943)
The Aero, 1914
Oil on canvas, 100.3 x 81.2 cm
Andrew W. Mellon Fund

Image courtesy of the National Gallery
of Art, Washington

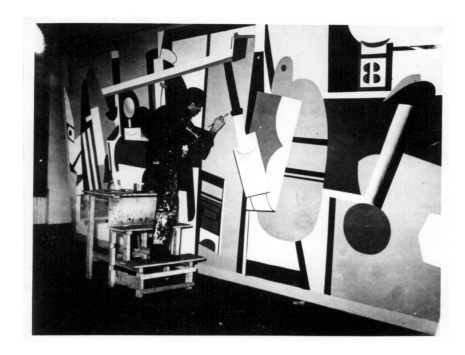

38
Arshile Gorky working on *Activities on the Field*, 1936
Federal Art Project, Photographic Division collection, Archives of American Art, Smithsonian Institution
© Georgia O'Keeffe Museum / DACS, 2012

The idea of making artworks which were visible only to flyers also emerged as a possibility at this time. Probably the earliest modern project of this sort was the Scottish architect Joseph Lea Gleave's winning entry for the Columbus Lighthouse Competition in Santo Domingo, Dominican Republic (1929–31). His scheme comprised a cruciform design to be viewed primarily from the air, from which vertical shafts of light would rise at night.[43] In the 1960s Robert Smithson also considered the idea of the possibilities afforded by the aerial view. Commissioned by an architectural and engineering firm to draw up proposals for the new Dallas-Fort Worth Airport, he used the opportunity to envisage the artworks and the space they would occupy as completely new experiences, in tune with the radical reorientation of vision suggested by air travel. He recommended that the airport be understood not so much as a place but as a vector of space and time, and he considered that its physical organization of space, based as it was on data from traffic flows, would "evade all our conceptions of nature":

The landscape begins to look more like a three-dimensional map than a rustic garden. Aerial photography and air transportation bring into

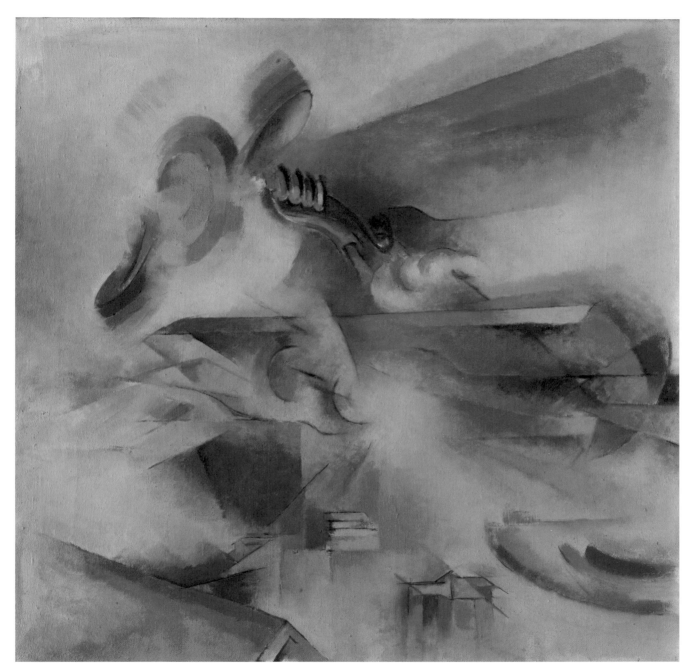

39

STANTON MACDONALD-WRIGHT (1890–1973)
Aeroplane Synchromy in Yellow-Orange, 1920
Oil on canvas, 61.6 x 61 cm
Metropolitan Museum of Art, New York,
Alfred Stieglitz Collection, 1949

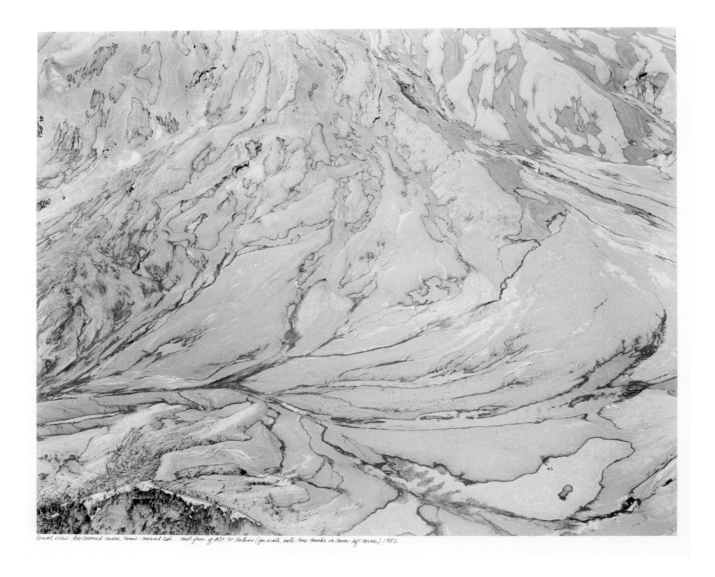

Aerial View: Ash-covered snow, snow-covered ash ... east face of Mt. St. Helens (for scale, note tree trunks in lower-left corner.) 1982

view the surface features of this shifting world of perspectives
The world seen from the air is abstract and illusive.[44]

Smithson therefore proposed making works of 'aerial art' that would
be seen from aircraft taking off and landing. The design he put forward used
interlocking triangles to make a spiral shape, anticipating his famous *Spiral
Jetty* of 1970.

40
FRANK GOHLKE (1942–)
*Aerial view: ash-covered snow,
snow-covered ash. East flank of
Mount St Helens, Washington*, 1982
Gelatin-silver print, 100.3 x 125.7 cm
Victoria and Albert Museum, London
© The artist

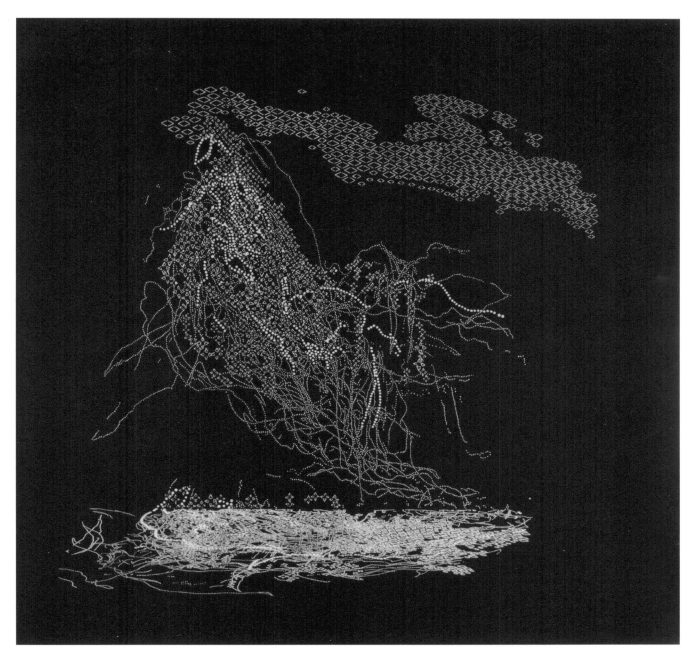

41

CLAUDE HEATH (1964–)
Ben Nevis on Blue, 2004
Acrylic on polyester, 180 x 186 cm
Government Art Collection
© The artist

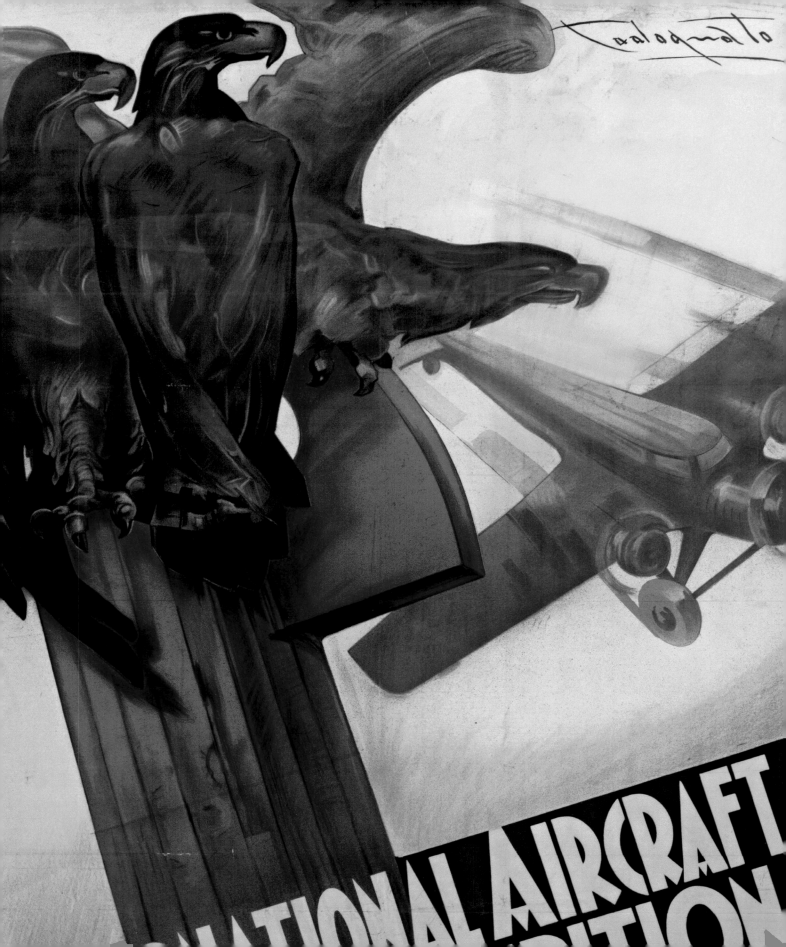

FLYING AND MODERNITY

The popularity of flying in its pioneering phases was a marked feature of the development of the new technology. Marcel Proust, born in the same year as Orville Wright, was caught up briefly in this enthusiasm; he paid for flying lessons for his beloved secretary Alfred Agostinelli in 1913, and had even arranged to buy him an aeroplane before Agostinelli drowned when his training flight crashed in the sea off Antibes in May 1914. Beyond this personal interest, aeroplanes were inescapably part of the modern world Proust anatomized in *A la recherche du temps perdu*. In a famous passage, he describes the flying angels in Giotto's frescoes in the Scrovegni Chapel, Padua, in thoroughly aviation-minded terms:

> They are real creatures with a genuine power of flight, we see them soar upwards, describe curves, 'loop the loop' without the slightest difficulty, plunge towards the earth, head downwards with the aid of wings, which enable them to support themselves in positions that defy the law of gravitation, and they remind us far more of a variety of bird or of the young pupils of Garros practising the *vol-plané*, than of the angels of the art of the Renaissance and later periods whose wings have become nothing more than emblems.[45]

As we have seen, large crowds had assembled to witness the early balloon flights. With the coming of the aeroplane in the early 1900s, the same enthusiasm resurfaced, with thousands of spectators attending the early French air shows and air races (the first of them, the Rheims air show of August 1909, attracted 500,000 visitors). Civilian air shows, races and derbies continued to be held in many towns in Europe and America over the next two decades. The Birmingham Air Pageant at Castle Bromwich aerodrome, for example, boasted 100,000 visitors over two days in July 1927,[46] while hundreds of thousands visited the annual RAF flying displays at Hendon (the first RAF Pageant took place at Hendon in 1920; the last was held in 1937; see fig. 43).

The Brescia air show of September 1909 was the first air display held in Italy. Its official programme, not entirely unexpectedly, included a scholarly article on Leonardo da Vinci's designs for a flying machine, a model of which

42
LÉON GIMPEL (1873–1948)
Paulhan sur biplan Voisin, Bétheny,
25 August 1909
Silver gelatin print
Société française de photographie
© *Ibid.*

had recently been displayed in the Milan *Esposizione Internazionale* (1906) as part of its Transport Retrospective.[47] The Brescia show has subsequently become famous not only for its place in aviation history but also because Franz Kafka, who was in the crowd, wrote an article on the event, and Gabriele d'Annunzio, who would go on to become an enthusiastic champion of Italian aviation, had his first successful trip as a passenger in an aeroplane there.[48] D'Annunzio's novel *Forse che sì, forse che no* (Maybe yes, maybe no), which was published the following year, concerns the rivalry between two airmen and makes a point of linking the myth of Daedalus and Icarus, via the researches of Leonardo da Vinci, to modern Italian aviation.[49]

Static aviation exhibitions were also popular. The first of them was mounted by the Aeronautical Society of Great Britain (established in 1866), which used the Crystal Palace in London to stage the *Aeronautical Exhibition* in the summer of 1868. The exhibition showed balloons, kites and "other aerial machines", and included a model of John Stringfellow's remarkably

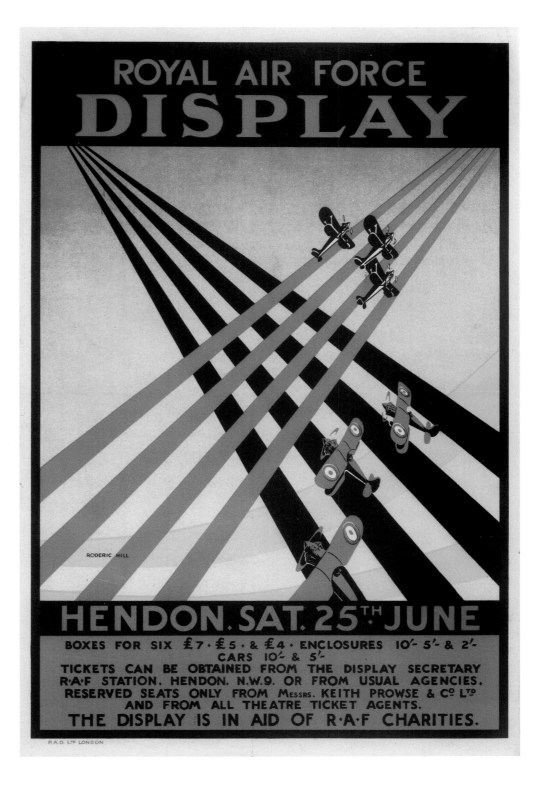

precocious steam-powered model triplane.[50] Once powered flight had been achieved, with the Wright brothers' successful flight at Kitty Hawk, North Carolina, in December 1903 and Wilbur Wright's demonstration flights in France of August 1908, the public's imagination was fired. A *Salon aéronautique* was held in Paris in the Grand Palais in December 1908 as part of an automobile show, and from 1909 the Grand Palais mounted an annual exhibition devoted solely to aviation: the *Exposition Internationale de locomotion aérienne*. In Paris in 1937, one of the pavilions in the *Exposition Internationale des arts et des techniques appliqués à la vie moderne* was the Palais de l'Air, a futuristic-looking building adorned with a mural designed by Robert and Sonia Delaunay.

In Italy an exhibition of Italian aeronautics opened in Milan's Palazzo dell'Arte in June 1934, and was seen by over a million visitors. Designed by the Rationalist architect Giuseppe Pagano, it included on its ground floor exhibits relating the history of flight from da Vinci's day to 1922, the year Mussolini came to power, and on the floor above a celebration of aviation under Fascism. At its centre was a two-storey cylindrical Hall of Icarus, to remind visitors symbolically of the risks taken by the pioneers of flight. A statue of Icarus by Marcello Mascherini looked across to a quotation from d'Annunzio:

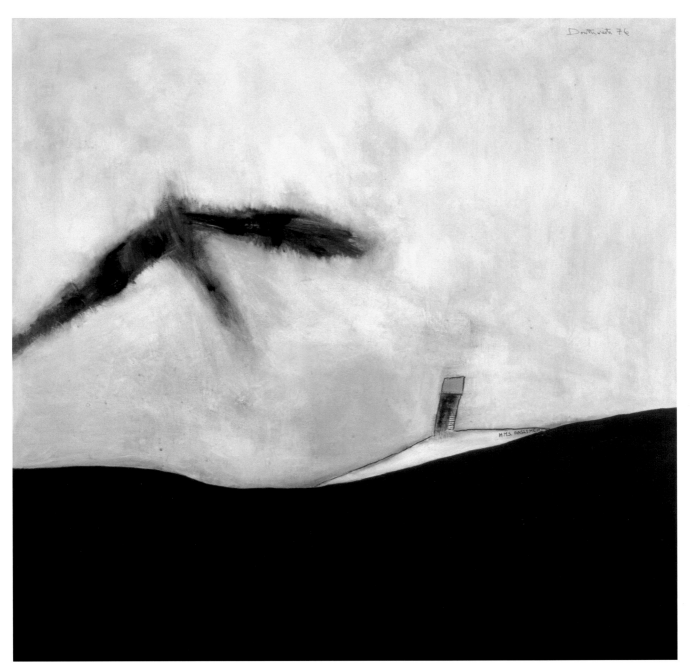

45

PAT DOUTHWAITE (1939–2002)
Death of Amy Johnson, 1976
Oil on canvas, 152.5 x 152.5 cm
Scottish National Gallery of Modern
Art, Edinburgh, purchased 1977
© Toby Hogarth

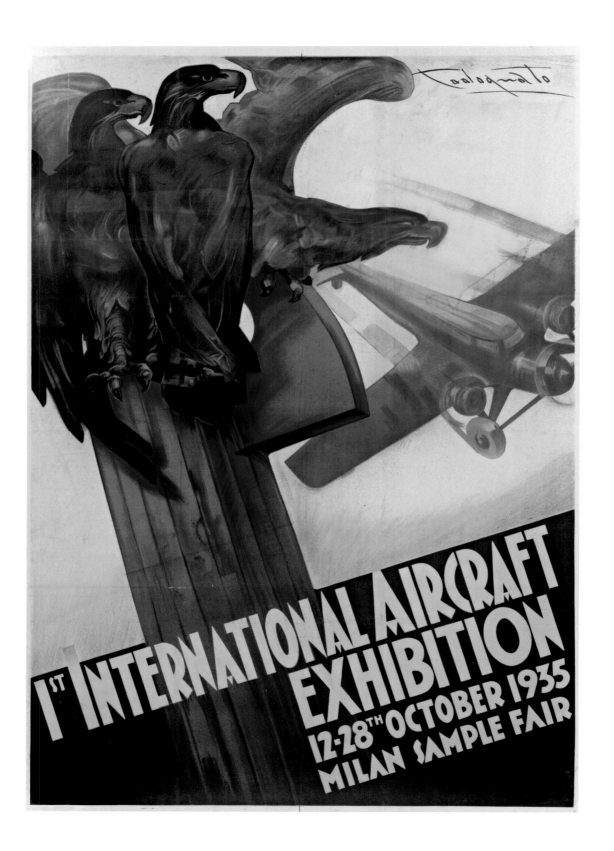

A limit to man's powers? No such thing exists. A limit to endurance? There's no such thing. I declare that the *ne plus ultra* is the most outrageous conceivable blasphemy pronounced against God.[51]

The exhibition was an important demonstration of the technological success of Mussolini's Italy, opening shortly after Italo Balbo's two trans-atlantic 'cruises': flying a flotilla of seaplanes from Italy to Brazil (in 1930–31) and from Rome to Chicago (in 1933).[52]

Films about flying also captured the public imagination. The Lumière brothers filmed a balloonist taking off in 1898 (*Départ d'une montgolfière*), as well as a view of the ground below (*Panorama pris d'un ballon captif*), in what was probably the first example of aerial cinematography. The first motion picture shots from an aeroplane were taken by cameramen on flights piloted by Wilbur Wright, near le Mans, for Pathé film in 1908, and near Rome on 24 April 1909 for the Italiana Pineschi film company.[53] Newsreel companies across Europe covered air shows and air races. Claude Grahame-White, who did much to develop the London aerodrome at Hendon, was filmed during the 1910 London to Manchester race between him and the French aviator Louis Paulhan, and the following year took a cameraman up to film over London.[54] By the 1930s ambitious documentaries were being produced recording new triumphs of aviation, such as *Wings over Everest* (1934), the Academy Award-winning film that recorded the Houston Everest Flight of 1933 – the first to cross the Himalayas.[55] Alexander Korda's *Conquest of the Air* of 1936 offered audiences the opportunity to reflect on the astonishingly rapid development of flying from its beginnings to the present day.

Feature films also began to exploit the potential for excitement that flying offered. In 1926 William Wellman directed the silent film *Wings*, a First World War drama starring Clara Bow. Army fighter pilots were employed for its action sequences and Harry Perry's camera, fitted with a gyroscope, gave audiences the thrill of seeing the earth rushing towards them as the plane dived. Howard Hughes's talkie *Hell's Angels* (1930), the film that made Jean Harlow an international star, was also set on the Western Front; the movie included even more spectacular effects of air combat, filmed by Elmer Dyer, the doyen of aerial cinematography.

WAR IN THE AIR

The possibility of using flying for military purposes was quick to develop. Initially it was the potential of the aerial view for tactical advantage that proved attractive. Balloon technology was encouraged by the Committee of Public Safety in revolutionary France after 1793, and in 1794 an 'Aerostatic Corps' was raised. An observation balloon was used in the decisive defeat of the Austrians by the French at the Battle of Fleurus on 26 June of that year. In the first phase of the American Civil War, the Union Army made use of balloons for observation and directing artillery fire, as did the British army in the Second Boer War of 1899–1902.

It became apparent towards the end of the nineteenth century that airborne munitions might also play a part in military engagements. Rockets designed by William Congreve had been used in the Napoleonic wars but, even with subsequent technical refinement, the tactical use of these projectiles was similar to that of conventional artillery. A flying machine able to drop bombs on a target below, however, offered a new dimension to military thinking. The American aeronautics inventor Russell Thayer proposed a 'dynamite balloon' (a steam-powered dirigible carrying a bomb) to the U.S. Navy, and in *Harper's Weekly* on 23 May 1885 a wood engraving of its destructive power was published – one of the earliest artistic renditions of air warfare (fig. 47).[55] Jules Verne, in his novel *Robur le Conquérant* of 1886, also anticipated the advent of war in the air, even though the fantastical clipper-helicopter he imagined as Robur's ship, the *Albatross*, was far beyond conventional technology (fig. 48). H.G. Wells, too, in his novel *When the Sleeper Wakes* (first serialized in 1898–99), looked forward with trepidation to the new threat from the skies, and followed it up with the explicit *War in the Air* (1908). Many shared Wells's views. The conventions adopted in the Hague Conference of 1899 prohibited balloons and airships from dropping projectiles and explosives; but in 1907 the Great Powers argued for a five-year renewal of the treaty rather than a permanent ban.

From very early on, the Wright brothers saw the potential of their new machine for military purposes, and in 1905 offered the Wright Flyer to the U.S. Army. They were initially turned down, but nevertheless developed a 'Military Flyer' in 1908; this was trialled in America and later demonstrated in Europe, but the Wrights still failed to win a contract. In 1909, however, the

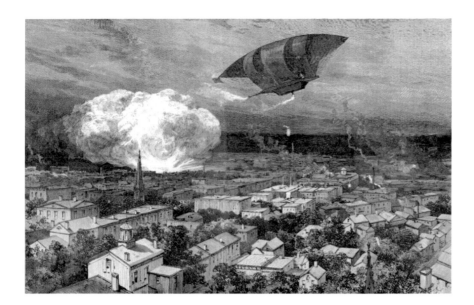

47
'The New Dynamite Balloon',
wood engraving from *The Inventor's
Sketches*, published in *Harper's
Weekly*, 23 May 1885

brothers successfully persuaded the Aeronautical Division of the U.S. Army
Signal Corps to adopt their invention. The militarization of the aeroplane
had begun. The first bombs were dropped from a plane in Libya, during the
Italian-Turkish War of 1911–12.

Although air combat, and the invention of the flying 'ace' for propa-
ganda purposes, dominate modern perceptions of flying in the Great
War, from the point of view of artistic influence it was the aeroplane's
reconnaissance role that was to prove influential. Cameras were used
extensively to produce stereoscopic photographs of the terrain below. Both
Richard Carline and his brother Sydney joined the Royal Flying Corps, and
were later appointed official war artists, concentrating on the war in the air.
The paintings both brothers produced often show the horizonless landscape
familiar to aerial reconnaissance (fig. 49). At first glance the resulting images,
with bomb craters and ruins patterning the surface, appear almost abstract .

Originally an architect, Cyril Power had repaired aeroplanes for the
Royal Flying Corps from 1916 until the end of the war. He then retrained as
an artist and began making linocuts in the 1920s, influenced by the leader of
the technique in Britain, Claude Flight. Flight was in turn inspired by Italian
Futurism, especially the Futurists' ambition to depict speed. Power's *Air Raid*
of *c.* 1935 (fig. 52), with its vertiginous spatial dynamics, can be compared

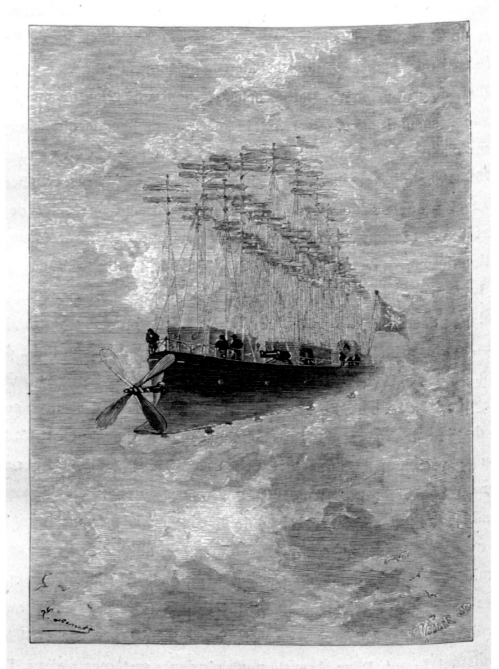

L'Albatros.

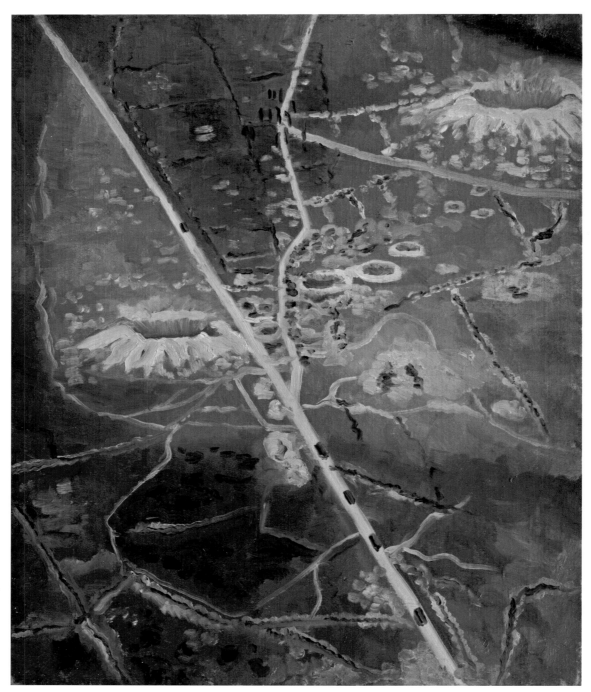

49
RICHARD CARLINE (1896–1980)
*Mine Craters at Albert, seen from
an Aeroplane*, 1918
Oil on canvas, 42.5 x 39.4 cm
Imperial War Museums
Imperial War Museums (Art. IWM ART LD 6346)
© Estate of the artist

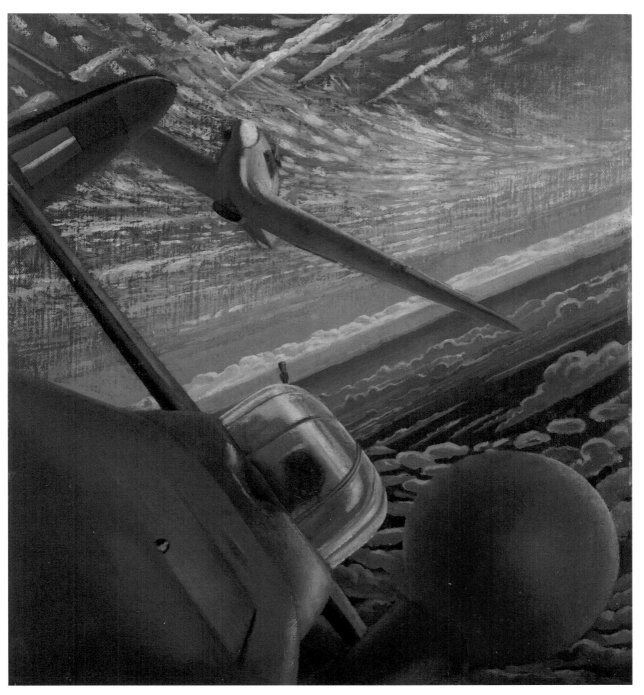

50
SIR WALTER THOMAS
MONNINGTON (1902–1976)
Fighter Affiliation: Halifax and Hurricane
Aircraft Co-operating in Action, 1943
Oil on canvas, 46.3 x 41.2 cm
Imperial War Museums

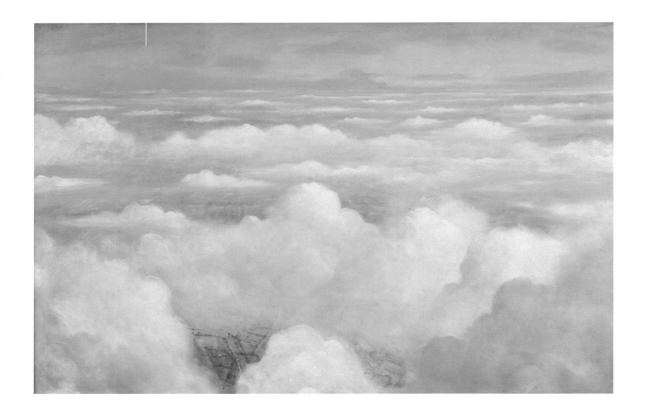

with the images produced by the Italian artists committed to Aeropittura. As with his Italian contemporaries, Power's image is troubling in its exuberance. It is at the very least ambiguous about the ethics of the conflict he depicts, for no target is visible.

The horrors of aerial attacks on civilian populations seen in the Spanish Civil War (the most notorious being the bombing of Guernica on 26 April 1937), and later in the Second World War, saw the triumph of aviation repositioned in a more uncertain context. Artists critical of military operations could use the aeroplane as a particularly effective symbol of aggression. James Rosenquist, for example, produced his vast painting *F-111* of 1964–65 during the Vietnam War, when machines like the F-111, the most advanced fighter-bomber in the U.S. Air Force, were being developed to improve low-level target penetration (fig. 53).[57] Rosenquist's twenty-three panels were designed to be shown on four walls, enclosing the viewer in a vivid demonstration of the intersection of military hardware with consumer capitalism.

51
CHRISTOPHER RICHARD WYNNE NEVINSON (1889–1946)
Battlefields of Britain, 1942
Oil on canvas, 122 x 184 cm
Government Art Collection
© Estate of C R W Nevinson / Bridgeman Art Library

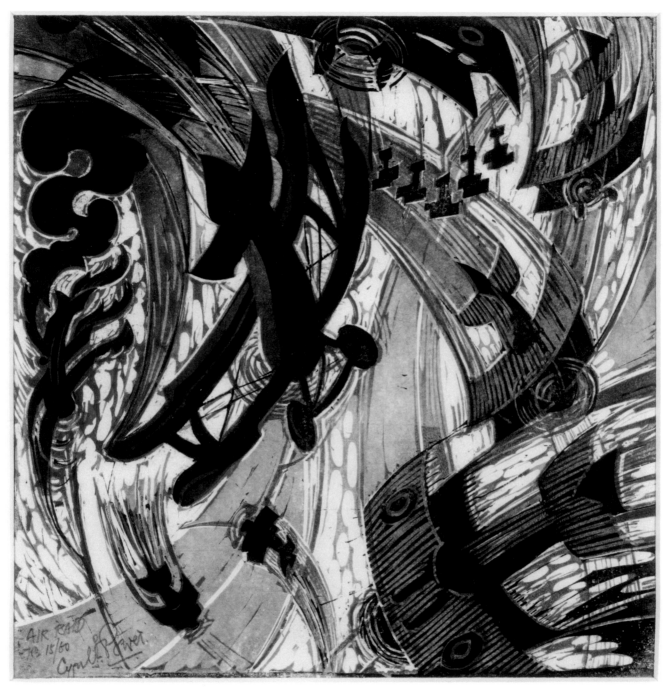

52
CYRIL POWER (1872–1951)
Air Raid, c. 1935
Linocut on paper, 55 x 50 cm
British Council Collection
© Estate of the artist / Bridgeman Art Library

53

JAMES ROSENQUIST (1933–)
F-111, whole and detail, 1964–65
Oil on canvas with aluminum,
304.8 x 2621.3 cm overall
Museum of Modern Art, New York (MoMA)

Purchase Gift of Mr and Mrs Alex L. Hillman
and Lillie P. Bliss Bequest

© 2012. Digital image. The Museum of Modern Art, New
York/Scala, Florence © James Rosenquist/ DACS, London/
VAGA, New York 2012

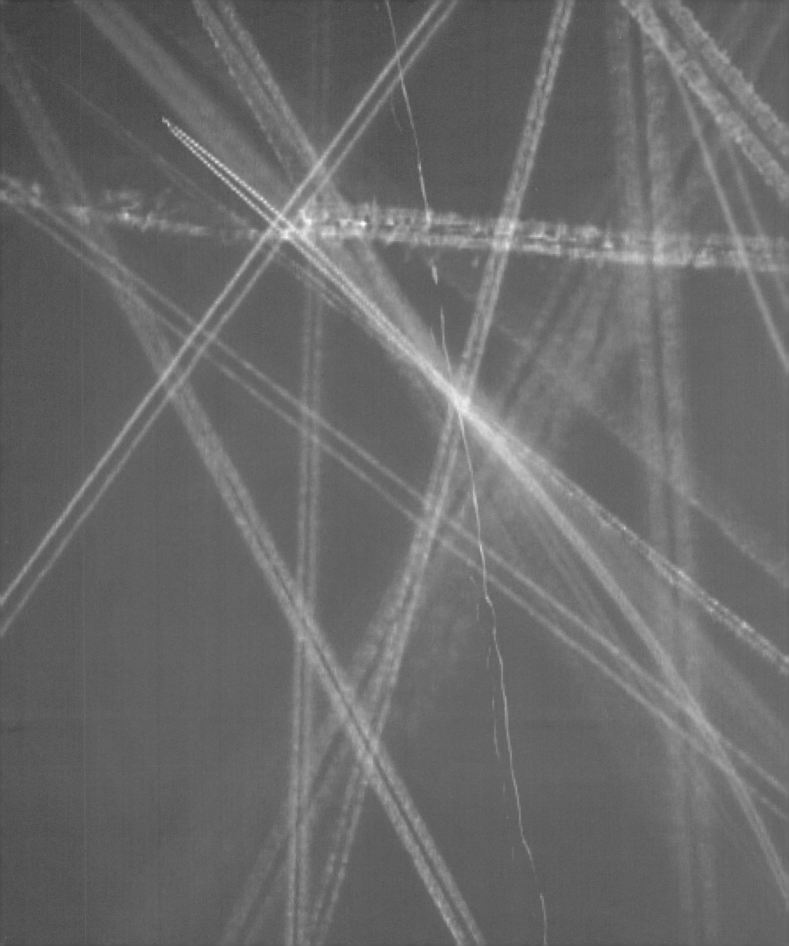

MARKING
THE SKY

As a by-product of aerial warfare, the sky became a tablet on which was impressed the traces of flight. Proust was struck by the spectacle of searchlights and the planes he saw overhead in Paris, defending the French capital from air attack, finding an unlikely aesthetic benefit in the fact that these "human shooting stars" helped Parisians appreciate the beauty of the sky, "towards which normally we so seldom raise our eyes".[58] The aestheticization of air combat is a recurrent feature in artistic responses to the war in the air. In his painting *Archies* of 1916, C.R.W. Nevinson painted anti-aircraft fire seen from below, the serene image of puffs of smoke and the aircraft high among them, almost invisible in a cerulean blue, contrasting ironically with the reality of danger and death (fig. 54). With the higher-flying aircraft of the Second World War, the tracks of aircraft across the sky were enhanced by the vapour trails produced at high altitude; both Paul Nash (fig. 55) and Richard Eurich (fig. 56) produced pictures making an explicit feature of these swooping contrails.

But the impact of aviation on the appearance of the skies is, of course, a much bigger phenomenon than the special circumstances of the two World Wars. The coming of flight has introduced new aerial bodies into the sky: balloons, dirigibles, airships, gliders, aeroplanes and helicopters. Now we take such sights for granted, and only notice their ubiquity when the skies clear – as in the wake of the 9/11 attacks or the shutdown of European airspace during the Eyjafjallajökull volcanic eruption of April 2010.

Hiraki Sawa's video *Dwelling* (2002), shot entirely indoors, uses models as an analogue for this incessant traffic and documents their activity with all the precision of a flight controller (fig. 58). In doing so, the almost ritual nature of this aerial circulation is made apparent: so many airborne bodies following prescribed routes in a ceaseless repetitious round, similar to the way our bodies move in their regular trajectories from room to room in our homes. Real planes feature in *Sky Drawings (Night/Day)* (2006), a video work by Layla Curtis, tracing the aircraft movements overhead in a single 24-hour period for one flight path (fig. 57). These fugitive traces in the sky are not only very beautiful; they may also be understood as indices of the mobility of the global population and the multicultural interconnectedness of the planet.

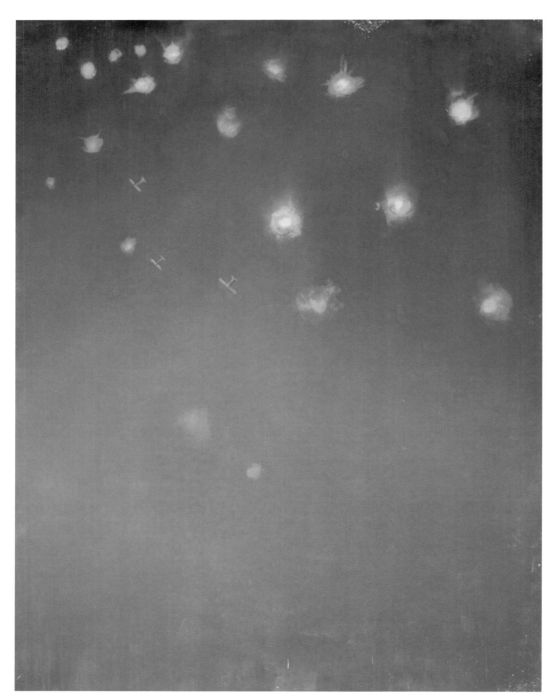

54
CHRISTOPHER RICHARD WYNNE
NEVINSON (1889–1946)
Archies, c. 1916
Oil on canvas, 62.8 x 48.2 cm
Imperial War Museums

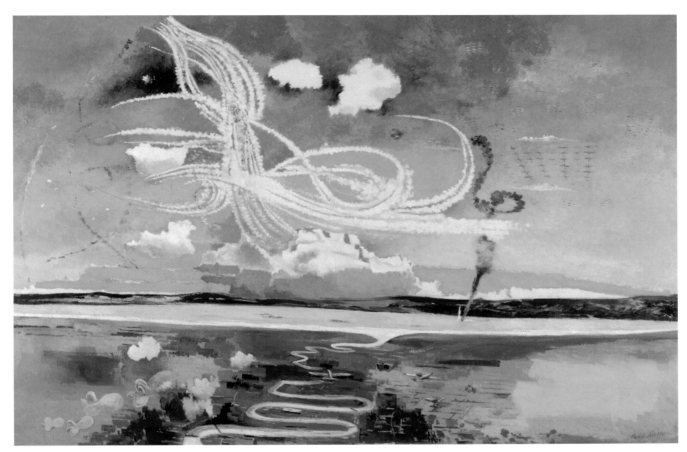

55

PAUL NASH (1889–1946)
Battle of Britain, 1941
Oil on canvas, 121.9 x 182.8 cm
Imperial War Museums

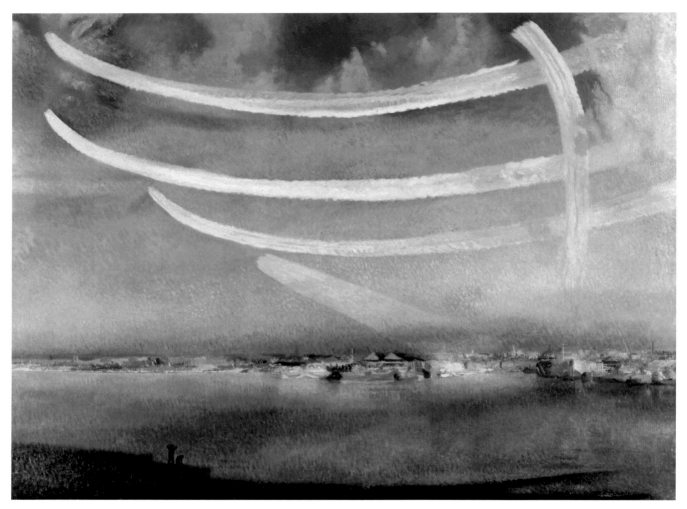

56
RICHARD EURICH (1903–1992)
Fortresses over Southampton Water, 1943
Oil on canvas, 76.2 x 101.9 cm
Imperial War Museums

© Imperial War Museums (Art. IWM ART LD 3958)

57
LAYLA CURTIS (1975–)
Sky Drawings (Night/Day), 2006
Video, duration 11 minutes
© The artist

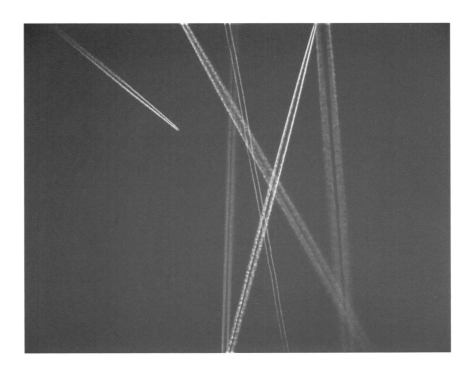

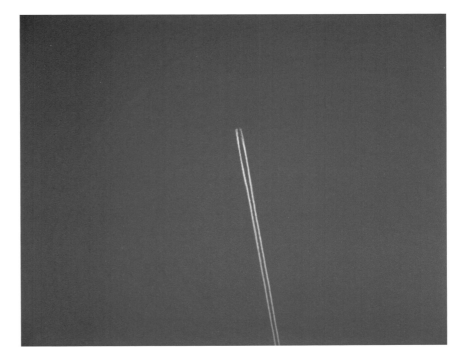

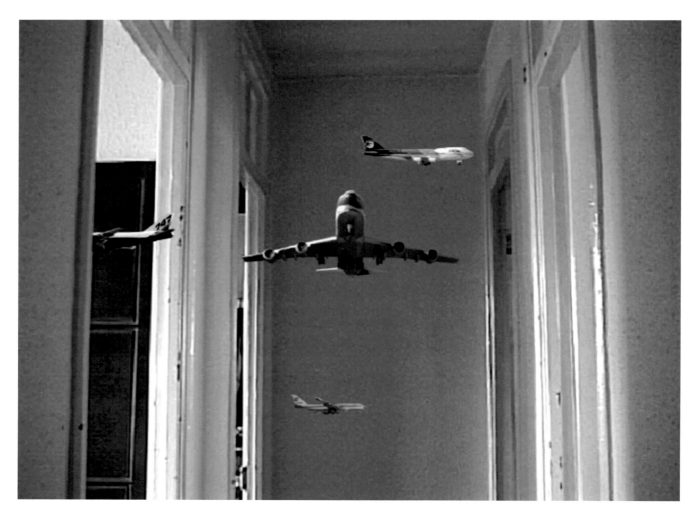

58
HIRAKI SAWA (1977–)
Dwelling, 2002
DVD, 9 minutes 20 seconds
Arts Council Collection,
Southbank Centre, London
© The artist

The purpose of this exhibition is, likewise, to pay attention to what has become overly familiar, to encourage us to raise our eyes to the skies and to reflect not only on the achievements of modern aviation but on the enormous impact flying has had and continues to have on visual culture.

59
MICHAEL LIGHT (1963–)
Full Moon # 82, 'Composite of Harrison Schmitt at Shorty Crater; Note Orange Soil / Photographed by Eugene Cernan, Apollo 17, December 7–9, 1972', 1999
Digital c-print
Victoria and Albert Museum, London
© The artist

1 Mark Holborn (ed.), *James Turrell Air Mass*, London: South Bank Centre, 1993, p. 15.

2 See Robert Wohl, *A Passion for Wings: Aviation and the Western Imagination, 1908–1918*, New Haven and London: Yale University Press, 1994, and Robert Wohl, *The Spectacle of Flight: Aviation and the Western Imagination, 1920–1950*, New Haven and London: Yale University Press, 2005.

3 James B. Pritchard (ed.) *Ancient Near Eastern Texts Relating to the Old Testament*, Princeton: Princeton University Press, 1969, pp. 101–03, 114–18.

4 *Genesis* 28:10–19.

5 The fact that the work is played backwards, however – such that motion up and down, and time before and after, are inverted – calls into question the nature of what we are experiencing and asks us to reflect on the nature of religious belief. See Tom Lubbock, 'Wallinger and Religion', *Modern Painters*, 14, no. 3, Autumn 2001, pp. 74–77.

6 Imam Bukhari, *Sahih al-Bukhari*, vol. 5, book 58, no. 227.

7 The idea probably derived from the depiction of griffins pulling chariots in Greek art. See Victor M. Schmidt, *A Legend and Its Image: The Aerial Flight of Alexander the Great in Medieval Art*, Groningen: Egbert Forsten, 1995.

8 The first known confession of such activity was made by a man, Guillaume Edelin, a priest from St Germain-en-Laye. A report of his trial in 1453 can be found in Thomas Johnes, *The Chronicles of Enguerrand de Monstrelet*, London: William Smith, 1840, vol. 2, p. 235.

9 Many of these are discussed by the anthropologist Berthold Laufer in his *The Prehistory of Aviation*, Chicago: Field Museum of Natural History, 1928. The book was written in the wake of Lindbergh's successful transatlantic solo flight of 1927.

10 For a review of these early experiments, see François Peyrey, *Les Oiseaux Artificiels*, Paris: H. Dunod & E. Pinat, 1909, p. 4.

11 See Domenico Laurenza, *Leonardo on Flight*, Baltimore: The Johns Hopkins University Press, 2004.

12 See Jyrki Siukonen, *Uplifted Spirits, Earthbound Machines: Studies on Artists and the Dream of Flight, 1900–1935*, Helsinki: Suomalaisen Kirjallisuuden Seura, 2001, pp. 121–71.

13 Alfred Lawson, 'Natural Prophecies', *Aircraft*, 6 October 1916; cited in Joseph J. Corn, *The Winged Gospel – America's Romance with Aviation*, Baltimore: Johns Hopkins University Press, [1983], 2001, pp. 40–41. See also Lyell D. Henry, *Zig-Zag-and-Swirl: Alfred W. Lawson's Quest for Greatness*, Iowa City: University of Iowa Press, 1991.

14 Compare the biblical story of the Devil transporting Jesus to a high mountain where he "shewed unto him all the kingdoms of the world in a moment of time", promising him dominion over them if Jesus would worship him; *Luke* 4: 5-7.

15 John Piper, 'Prehistory from the Air', *Axis*, 9, Early Winter 1937, pp. 4–8. For the use of aerial survey in archaeology, see Helen Wickstead and Martyn Barber, 'A Spectacular History of Survey by Flying Machine!', *Cambridge Archaeological Journal*, 22, no. 1, February 2012, pp. 71–88; Kitty Hauser, *Shadow Sites: Photography, Archaeology, & the British Landscape 1927–1955*, Oxford: Oxford University Press, 2007.

16 The first successful manned balloon ascents occurred on 19 October (tethered) and then free-flying on 21 November 1783.

17 The best account of the development of balloon flight is L.T.C. Rolt, *The Aeronauts: A History of Ballooning, 1783–1903*, London: Longmans, 1966.

18 Thomas Baldwin, *Airopaidia, Containing the Narrative of a Balloon Excursion from Chester*, Chester, 1786.

19 Vincent Lunardi, *An Account of the First Aerial Voyage in England*, London, 1784.

20 Nadar's photograph has disappeared, but one of Black's photographs exists in two versions. Nadar made further photographs of Paris from 1868 which have survived. See Beaumont Newhall, *Airborne Camera: The World from the Air and Outer Space*, London and New York: Focal Press, 1969, pp. 19–33. Nadar also promoted heavier-than-air flight and in 1863 founded the International Society for the Encouragement of Aerial Locomotion by means of Apparatus heavier than the air. See Nadar, *The Right to Fly*, London: Cassell, Petter and Galpin, 1866.

21 See Newhall 1969, pp. 34–48.

22 Spelterini was a noted aeronaut, making the first crossing of the Alps by balloon in October 1898. See Eduard Spelterini, *Über den Wolken/Par dessus les nuages,* Zürich: Brunner & Co, 1928; also Hillar Stadler, *Eduard Spelterini: Photographs of a Pioneer Balloonist*, Chicago: University of Chicago Press, 2012 and Hillar Stadler, *Eduard Spelterini and the Spectacle of Images: The Colored Slides of the Pioneer Balloonist*, Zurich: Verlag Scheidegger und Spiess, 2010.

23 See Celia Ferguson, *A Vision of Flight: The Aerial Photography of Alfred G. Buckham*, Stroud: The History Press, 2008.

24 John Gage, *Collected Correspondence of J.M.W. Turner*, Oxford: Clarendon Press, 1980, p. 163. New research on this letter, including its correct dating as March 1837, is contained in Brian Riddle, 'Turner and Aerostation', *Turner Society News*, 116, Autumn 2011, pp. 14–18.

25 See Erkki Huhtamo, 'Aeronautikon! or, The Journey of the Balloon Panorama', *Early Popular Visual Culture*, 7, no. 3, 2009, pp. 295–306.

26 [T.M. Monck Mason], *Account of the Late Aeronautical Expedition from London to Weilburg*, London: F.C. Westley, 1836, pp. 21–22.

27 Peter Lanyon, 'An Illustrated Slide Lecture on English Landscape', typescript, 1964, collection of Sheila Lanyon; quoted in Margaret Garlake, *Peter Lanyon*, London: Tate Publishing, 1998, p. 7.

28 Peter Lanyon talking to Lionel Miskin about his early life etc., 1962 Tate Gallery Archive, TAV 211 AB.

29 Filippo Tommaso Marinetti, 'Founding Manifesto of Futurism', *Le Figaro*, 20 February 1909, quoted in Umbro Apollonio (ed.), *Documents of 20th Century Art: Futurist Manifestos*, New York: Viking Press, 1973, pp. 19–24.

30 See *Futurism in Flight : "Aeropittura" Paintings and Sculptures of Man's Conquest of Space (1913–1945)*, Rome: De Luca, 1990. The 1929 manifesto can be found online at http://www.culturaservizi.it/vrd/files/VN1931_manifesto_aeropittura.pdf

31 See Christina Lodder, 'Malevich, Suprematism and Aerial Photography', *History of Photography*, vol. 28, no. 1, Spring 2004, pp. 25–40.

32 Ivan Aksenov, *Pikasso i okrestnosti* [Picasso and environs], Moscow: Tsentrifuga, 1914; quoted in Lodder 2004, p. 26.

33 Kasimir Malevich *The Non-Objective World* [first published in German, 1927], New York: Paul Theobald & Co., 1959, pp. 74–76; quoted in Lodder 2004, p. 37.

34 Arsène Alexandre, 'L'art et l'air', *Comoedia*, 23 and 30 October 1909.

35 See Wohl 1994, pp. 2–53 *passim*.

36 Cited in Dora Vallier, 'La Vie fait l'oeuvre de Léger: propos de l'artiste recueillis par Dora Vallier', *Cahiers d'Art*, 29, no. 2, 1954, p. 140. Most historians date this event to 1912; Jyrki Siukonen, however, thinks the visit may have taken place in 1909; see Siukonen 2001, pp. 180–83.

37 On this see Christoph Asendorf, 'The Propeller and the Avant-garde: Léger, Duchamp, Brancusi', in Dorothy Kosinski (ed.), *Fernand Léger 1911–1924: The Rhythm of Modern Life*, Munich and New York: Prestel, 1994, pp. 203–09.

38 See Elizabeth Mankin Kornhauser (ed.), *Marsden Hartley*. New Haven: Yale University Press, 2003.

39 Published in *Ace: The Aviation Magazine of the West* 1, no. 2, September 1919, pp. 11–12.

40 Exhibited in *Exhibition of Paintings by American Modernists*, Museum of History, Science and Art, Los Angeles, 1–29 February 1920, no. 65 (as *Aeroplane Synchromy (Yellow-Orange)*).

41 Gorky had previously been involved with a project for another airport serving New York, Floyd Bennett Field, but his proposal was not accepted. He completed the Newark commission in 1937. In 1941 the airport was handed over to the military and in 1948, when it returned to civilian use, the murals were discovered to have been painted over. See Matthew Spender, *From a High Place: A Life of Arshile Gorky*, Berkeley and Los Angeles: University of California Press, 1999.

42 See Matthew Spender (ed.), *Arshile Gorky: Goats on the Roof; A Life in Letters and Documents*, London: Ram Publications, 2009, pp. 85–89.

43 See Charles Waldheim, 'Aerial Representation and the Recovery of Landscape', in James Corner (ed.), *Recovering Landscape:*

Essays in Contemporary Landscape Architecture, New York: Princeton Architectural Press, 1999, pp. 122–23. The foundations were inaugurated in 1948 but the lighthouse was not actually constructed until 1986-92.

44 The firm for whom Smithson was consultant failed to win the commission and the project was unrealised. See Robert Smithson, 'Aerial Art', *Studio International*, 175, no. 89, February-April 1969, pp. 180–81; also Robert Smithson, 'Towards the development of an Air Terminal Site', *Art Forum*, 6, no. 10, June 1967, pp. 36–40, both reprinted in Jack Flamm (ed.), *Robert Smithson: The Collected Writings*, Berkeley: University of California Press, 1996, pp. 116–18 and 52–60.

45 Marcel Proust, *Albertine Disparue*, 1925, translated by C.K. Scott Moncrieff as *The Sweet Cheat Gone*, London: Chatto and Windus, 1930, pp. 318–19. "Garros" is a reference to the French airman Roland Garros, killed in action in 1918; *vol-plané* means 'gliding flight'.

46 See *Flight*, 19, no. 29, 21 July 1927, pp. 489–90, 492–97; also Jack Williams, 'The upper class and Aeroplane Sport Between the Wars', *Sport in History*, 28, 2008, pp. 450–71.

47 Luca Beltrami, 'L'Aeroplano di Leonardo', reprinted in Edmondo Solmi *et al*. (eds.) *Leonardo da Vinci – Conferenze Fiorentine*, Milan: Fratelli Treves, 1910, pp. 313–26.

48 See Peter Demetz, *The Air Show at Brescia, 1909*, New York: Farrar, Straus and Giroux, 2002.

49 After the outbreak of the Great War, d'Annunzio learned to fly and took part in combat missions as an observer or bombardier. He persuaded the Italian high command to undertake a famous propaganda exercise on 9 August 1918, flying with the 87th Squadron to drop leaflets on Vienna.

50 Stringfellow is one of the pioneers of powered flight. In 1842, working with W.S. Henson, he designed the prototype model of the aerial steam-powered triplane. Its engine was too heavy to allow flight, but a revised version of the design produced in 1848 was more successful.

51 "Limite delle forze? Non v'è limite delle forze. Limite del patimento? Non v'è limite del patimento. Dico che il non più oltre è la bestemmia al Dio più oltraggiosa", in *Esposizione dell'Aeronautica Italiana*, 1934, p. 135; cited in Jeffrey T. Schnapp, 'Mostre', in Hans-Jorg Czech and Nikola Doll (eds.), *Kunst und Propaganda im Streit der Nationen 1930–1945*, (Deutsches Historisches Museum, Berlin), Dresden: Sandstein Verlag, 2007, pp. 78–85; also available online at http://jeffreyschnapp.com/wp-content/uploads/2011/07/Mostre.pdf.

52 Balbo was Minister of the Air Force and a key member of the Fascist party.

53 The Pathé film is only known from a still, published in the Christmas 1908 edition of *La Vie au Grand Air* (illustrated in Newhall 1969, p. 49). In Italy, Wright had been invited by the newly formed Club Aviatori, to demonstrate his Military Flyer at the Centocelle military base. A selection of early aviation films can be viewed online at *http://invention.psychology.msstate.edu/moviesandphotos/index.html*

54 See Michael Paris, *From the Wright Brothers to Top Gun – Aviation, Nationalism and Popular Cinema*, Manchester: Manchester University Press, 1995.

55 Two Westland Biplanes made the attempt, powered by Bristol Pegasus engines. The symbolism of the engine name was, of course, intentional.

56 Thayer's general interest in steam-powered flight is seen in his paper 'Aerial Ships', read before the American Philosophical Society on 16 November 1883, and reprinted in *Proceedings of the American Philosophical Society*, 21, no. 114, March 1883.

57 General Dynamics's F-111 first flew in 1964 and entered operational service in the United States Air Force in 1967. It was first deployed in Vietnam the following year, but was not fully operational until 1971.

58 Marcel Proust, *Le Temps Retrouvé* (1927), translated by Andreas Mayor as *Time Regained*, London: Chatto and Windus, 1970, p. 137.